John Taylor

ICON PAINTING

MAYFLOWER BOOKS
NEW YORK

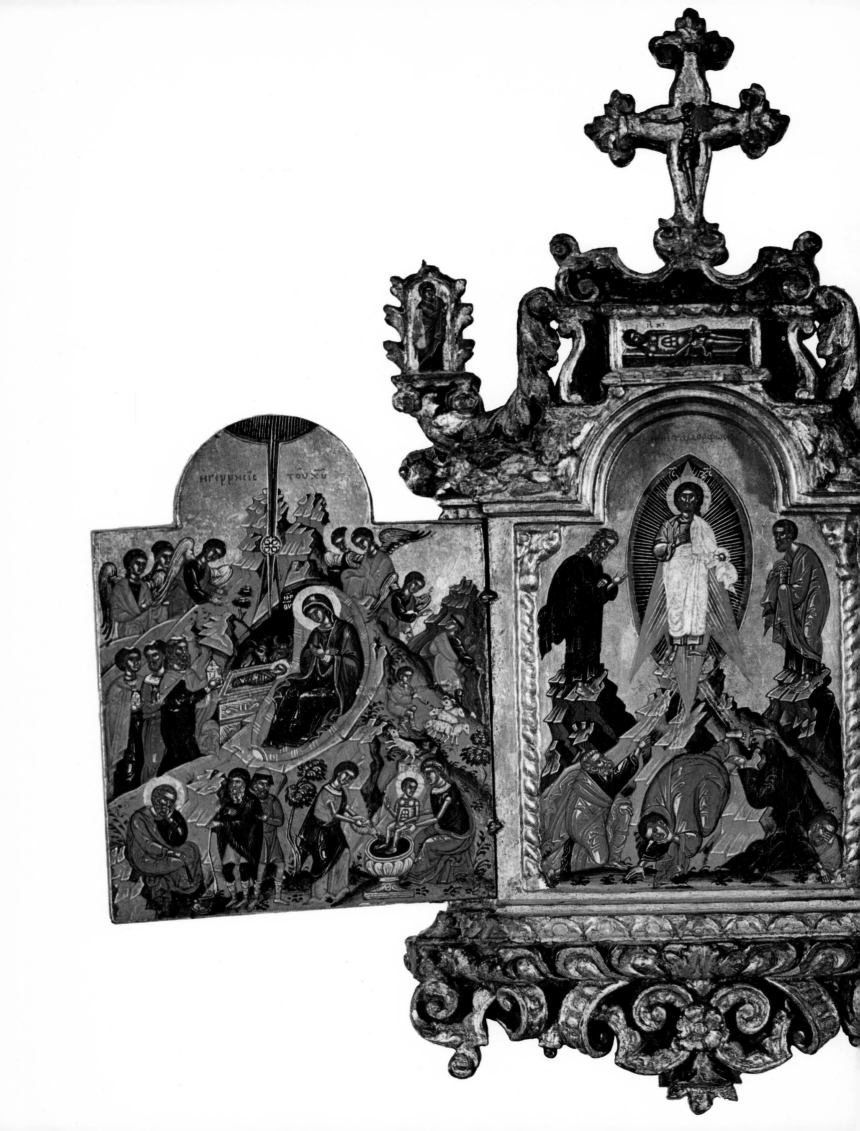

John Taylor

ICON PAINTING

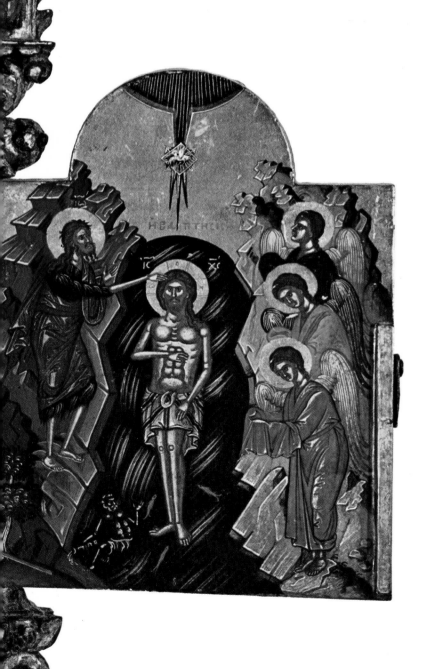

OVERLEAF *Scenes from the Life of Christ*, School of the
Greek Islands, 39 × 42cm, 17th century

MAYFLOWER BOOKS, INC.,
575 Lexington Avenue, New York City 10022.

© 1979 by Phaidon Press

All rights reserved under International and Pan
American Copyright Convention.
Published in the United States by Mayflower Books,
Inc., New York City 10022.
Originally published in England by Phaidon Press,
Oxford.

Library of Congress Cataloging in Publication Data

 TAYLOR, JOHN, 1945–
 Icon painting.

 1. Icon Painting – History. 2. Orthodox
Eastern Church and Art – History. I. Title.
II. Series.
N8187.T38 755′.2 78–25925
ISBN 0–8317–4813–3
ISBN 0–8317–4814–1 pbk.

Filmset in England by SOUTHERN POSITIVES AND NEGATIVES
(SPAN), *Lingfield, Surrey*
Manufactured in Spain by HERACLIO FOURNIER SA, *Vitoria.*
First American edition

In 330 AD, in the small port of Byzantium, on the shores of the Bosphorus, Constantine the Great established the new capital of the Roman Empire. Two hundred years later, the city of Constantinople was able to vie with Rome in greatness. The new centre of the empire attracted the great families of Rome, and the armies of craftsmen and artisans from Europe and Asia Minor, anxious to serve them and the new religion of Christianity. They brought their skills, and put them at the service of the material and spiritual wealth of the empire.

The public works of the period include bronze statues, mosaics, and glorious churches, but it is the art of icon painting that has a special interest. For these pictures, often extremely beautiful, expressed, and continue to express — because icons are still being painted — the aspirations of people towards the divine.

Icons were often painted by monks, who were thought to be divinely inspired, and so we shall examine the fortunes of monks and the role of holy men and hermits, as well as the importance invested in Christianity by the state as an aid to its claim for temporal power.

The making and position of icons

The word 'icon' means image, picture, or likeness. Originally, the term referred to all depictions of religious subjects; now, its significance has become restricted, and it denotes a portable religious picture, either painted on a wooden panel, or in enamel on metal, or executed in mosaic. Unless made for use in processions, most wooden panels were painted on one side only.

The selection of wood was of the greatest importance, as resinous wood was apt to harbour woodworm. Most favoured were the non-resinous woods such as lime, alder, birch and cypress; pine was used in Russia, where it tended to be less resinous than in the Mediterranean. The panel was cut to size, and in most cases a flat surface was hollowed out from the centre in order to provide a raised border. This practice also made warping less likely. However, some icons have a completely flat surface.

The next step was to cover the panel with a sheet of loosely-woven canvas that was treated with a mixture of gesso and powdered alabaster, or the finest grade of chalk. This was laid on in layers, each of which was allowed to dry before the application of the next, until there were about eight layers. On the resulting smooth surface the artist painted.

The earliest known icons, from the sixth century, are painted in a hot wax process called encaustic. For a while this method existed alongside a subsequent process of painting in egg tempera, which by about the eighth century

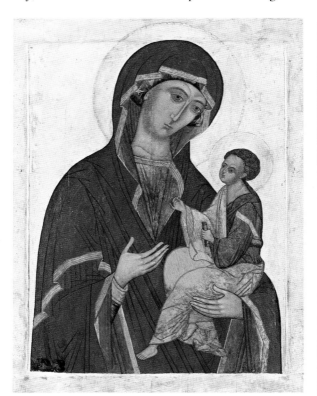

Madonna Vadstena, Russian, 118 × 92cm, 16th century

The Mother of God holds the infant Jesus on her left arm, and points to him with her right hand. Her head is inclined towards his, and because her eyes are not directed at the onlooker or on Christ she has a remote and pensive air. The Christ Child looks to the right, and his eyes too are not directed outside the picture. He blesses with his right hand, and holds a scroll in his left. He is a type of Christ-Emmanuel (Isaiah 7:14), a philosopher-king, full of wisdom. Although Mary offers a gesture of presentation, this icon is not the full Hodegitria type, such as the *Virgin and Child* from the School of Salonica, since neither figure is looking out of the picture. The Hodegitria type means that the icon is a 'guide' or 'indicator of the way'. The first icon was supposed to have been of this type, and it was painted from life by St. Luke. The Mother of God was supposed to have blessed the portrait and said, 'My blessing will remain always with this icon.' Luke sent the portrait to Antioch with the text of his gospel. It remained there until the middle of the fifth century, when it was taken to Constantinople and placed in a monastery founded by Pulcheria, sister of Theodosius II.

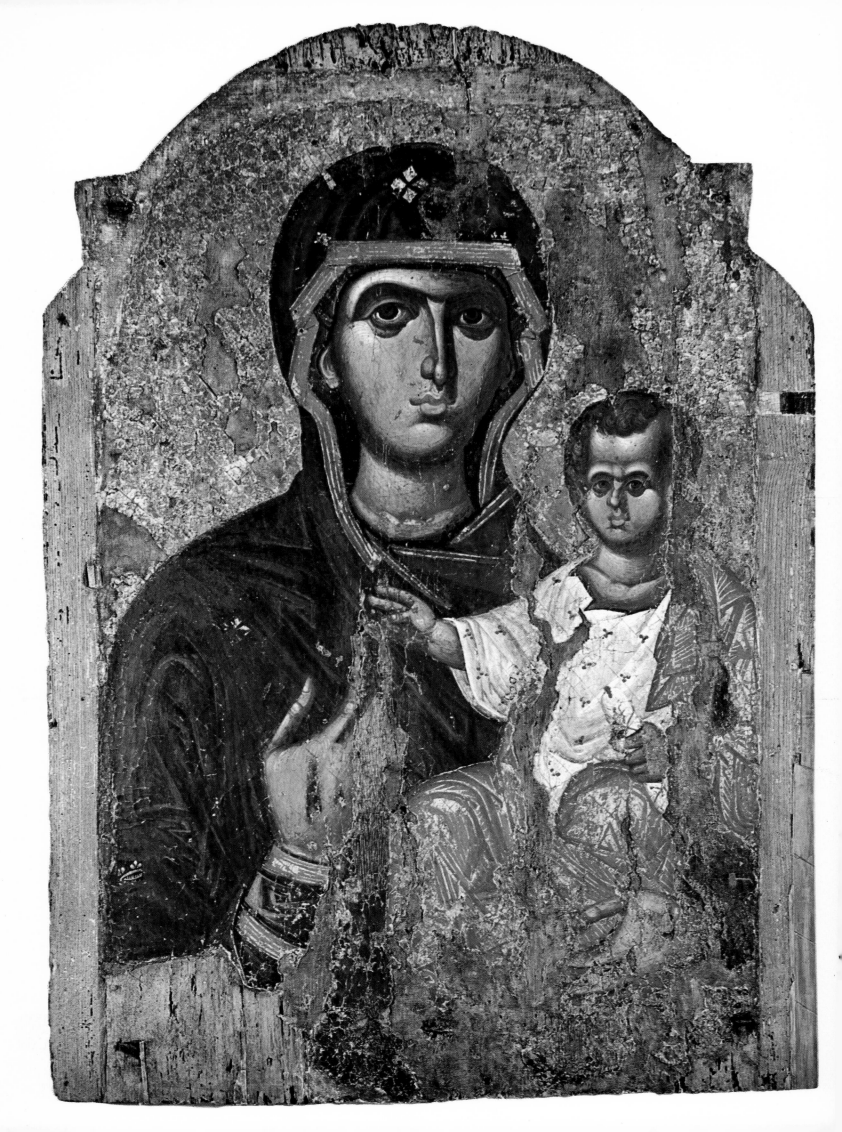

appears to have superseded it. In the fifteenth century, oil painting was developed, but this never achieved the popularity of egg tempera amongst the icon painters. Unfortunately, amateur restorations of tempera painting have sometimes been carried out in oil paint.

Finally, the finished painting was given a coat of varnish. Since the varnish absorbs dust and soot from its surroundings, the brilliant colours soon began to darken and recede, and the custom of covering an icon with an ornate sheet of precious metal developed, so that only the most significant parts were left visible. It is possible to remove the ancient varnish, so as to restore the colours to their original brilliance.

The Byzantine theory of colour was rooted in the tradition of alchemy. Because the function of icons to display, for example, Christ or the Virgin as intercessor was sometimes forgotten, and miracles were attributed to the icon itself, it seemed necessary for the artist to understand the spiritual properties of matter. If colour was produced by some unknown chemical process, brought about by mixing together various different substances, then there had to be strict rules about its use.

The colour symbolism was not particularly abstruse: green and brown represented the earth and vegetation; blue was a sign of heaven and contemplation; scarlet red meant strength or the blood of martyrs, while deep red stood either for the Imperial purple, or for the blood of Christ. White indicated purity, and the invisible presence of God; it was used for the vestments of the Bishops. Gold represented magnificence, or perhaps the sun or divine energy.

Until the sixteenth century the subject matter was restricted to scenes from the Old and New Testaments, and from the lives of the saints. It was not until this time, when Constantinople had been under Turkish rule for two centuries, that the canon was expanded to include scenes of the Apocrypha and of the lives of obscure local saints. The earliest icons are confined to depictions of Christ, the Virgin Mary, and important saints such as Peter and Paul. But a

later significant development was the choice by theologians of ten or twelve major feasts of the New Testament. Consequently, artists began to portray such scenes as the Annunciation, the Nativity, the Presentation of Christ in the Temple, the Baptism, the Transfiguration, the Raising of Lazarus, the Entry into Jerusalem, the Crucifixion, the Resurrection and Descent into Limbo, the Ascension, the Pentecost, and the Assumption or Dormition of the Virgin.

Just as the colours chosen for the paintings had spiritual force, so there was spiritual significance in the architecture of the churches in which they were placed. The paintings ornamented the iconostasis, a wooden screen dividing the nave, symbolizing the realm of physical man, from the sanctuary, which stood for the realm of the spirit. The iconostasis was a reflection of the inseparable nature of the two worlds, representing their unity and reconciliation.

The form of iconostasis developed gradually. It had been customary in the earliest Christian basilicas to divide the

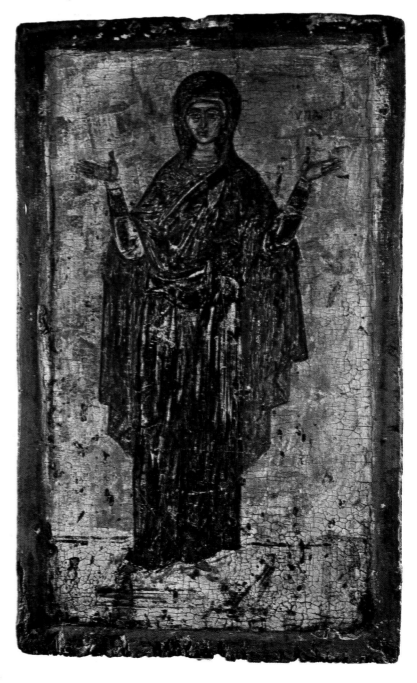

OPPOSITE *Virgin and Child*, School of Salonica, 82 × 58cm, 14th century

Virgin Orans, School of Constantinople, 55 × 32cm, 13th–14th century

The Virgin stands and faces to the front with both arms raised on either side. This is an ancient gesture of prayer, and was a symbol of piety, which later characterized pious individuals, such as saints or martyrs. In the dome of the Church of St. George in Thessalonika, from the fourth century, martyred saints without haloes adopt this posture. The Virgin Mary in prayer recalls her gesture of submission at the Annunciation as a vessel of the Incarnation of God. Mary is also depicted in this way in scenes of the Ascension, as in the Rabula Gospels, 586, where she testifies to the second coming by making the gesture of submission that, at the Annunciation, she used to indicate the first coming. The Virgin *orans* can be seen in a wall painting in a catacomb of the fourth century at the Via Nomentana, Rome.

church into two parts. This was originally accomplished with a screen of solid low walls, to which was later added a row of columns with an architrave or entablature above. The spaces between the columns were occupied by curtains in the earliest churches, but by the twelfth century they were filled by wooden panels. Large icons would have filled any suitable space on a wall or column. In the basilica of St. Demetrius in Thessalonika, votive mosaics of the saint illuminate the walls and piers; in other churches there were icons painted on wood in these spaces. Paul the Silentiary writing about St. Sophia in Constantinople in 563, said:

> Not only upon the walls which separate the priest from the choir of singers has he set plates of naked silver, but the columns too, six sets of twain in number, he has completely covered with the silver metal, and they send forth their rays far and wide. Upon them the tool wielded by a skilled hand has artfully hollowed out discs more pointed than a circle (oval), within which it has engraved the figure of the immaculate God, who, without seed, clothed himself in human form.

It is clear from this that the first icons were hung upon the columns, not between them. Subsequently, the use of latticed

Crucifixion, Byzantine, 105 × 65cm, 9th–13th century

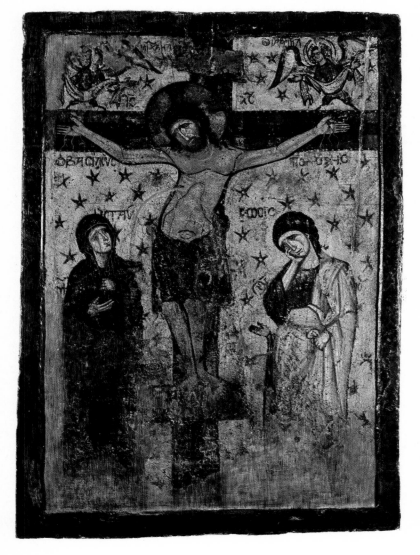

screens of precious materials, sculpture and painted images became widespread. The earliest screens encompassed the area of the altar only, but later screens were enlarged to conceal the two rooms on either side of the apse from the view of the congregation. The pattern of representation on the iconostasis gradually became fixed. It was usual for the central or Royal doors to be decorated with icons of the Annunciation and the four Evangelists. Above this one might find the scene of the Last Supper, and on the jambs of the door would be represented various Holy Fathers. To the right of this door would be either an image of Christ, or a dedicatory icon in honour of the saint after whom the church was named. To the left, one might expect to see an icon of the Mother of God. The north and south doors of the sanctuary were decorated with sainted deacons or archangels, and the outer edges of the screen might be filled with any other icons. Above the Royal door there would be a Deisis, which is an image of Christ seated with Mary on his right hand and John the Baptist on his left. This section would be filled to the edges with a row of saints. Above them would appear the scenes of liturgical feasts, above these a row of prophets, and finally a row of patriarchs.

In Russian Churches, the iconostasis came to extend the whole height of the church, and completely closed off the sanctuary from the nave. It was a more intimidating barrier between the earthly and heavenly realms than was first envisaged by the early church.

Early Christian practices

The religious imagery used by the Byzantines had to be effective on different levels. Its meaning had to reach the many peoples of the Empire; it had to be effective for intellectuals wrestling with biblical exegesis; it had to illustrate stories for those people who could not read, and it had to reinforce the hierarchy of the state. Its final form was an expression of the many sources on which it drew, a fusion of the religious ideas of pagan, Jew, and Christian.

The first Christians were converted Jews, and their religion had to flourish in the context of the Old Testament Law and the prohibition of images.

> You shall not make yourself a graven image, or any likeness of anything that is in heaven above, or that is in the earth beneath, or that is in the water under the earth: you shall not bow down to them or serve them (Exodus 20:4–5).

Consequently, there were no images in the Temple of Jerusalem during the Hellenic and Roman periods. In Syria, however, at a place called Dura Europos near Damascus, incorporated into a sloping defensive wall, are the ruins of a synagogue and a church, destroyed in 257. Both of these contained images. The synagogue was decorated with episodes from the Holy Scripture of the Hebrews, drawn in a linear and flat style similar to the pictures in a neighbouring pagan temple dedicated to the Palmyrene Gods. The figures in the temple are rigid, juxtaposed frontally, and drawn in a linear, two-dimensional manner, just as the votive mosaics were depicted in the Church of St. Demetrius, Thessalonika,

OPPOSITE *Crucifixion* (detail of St. John)

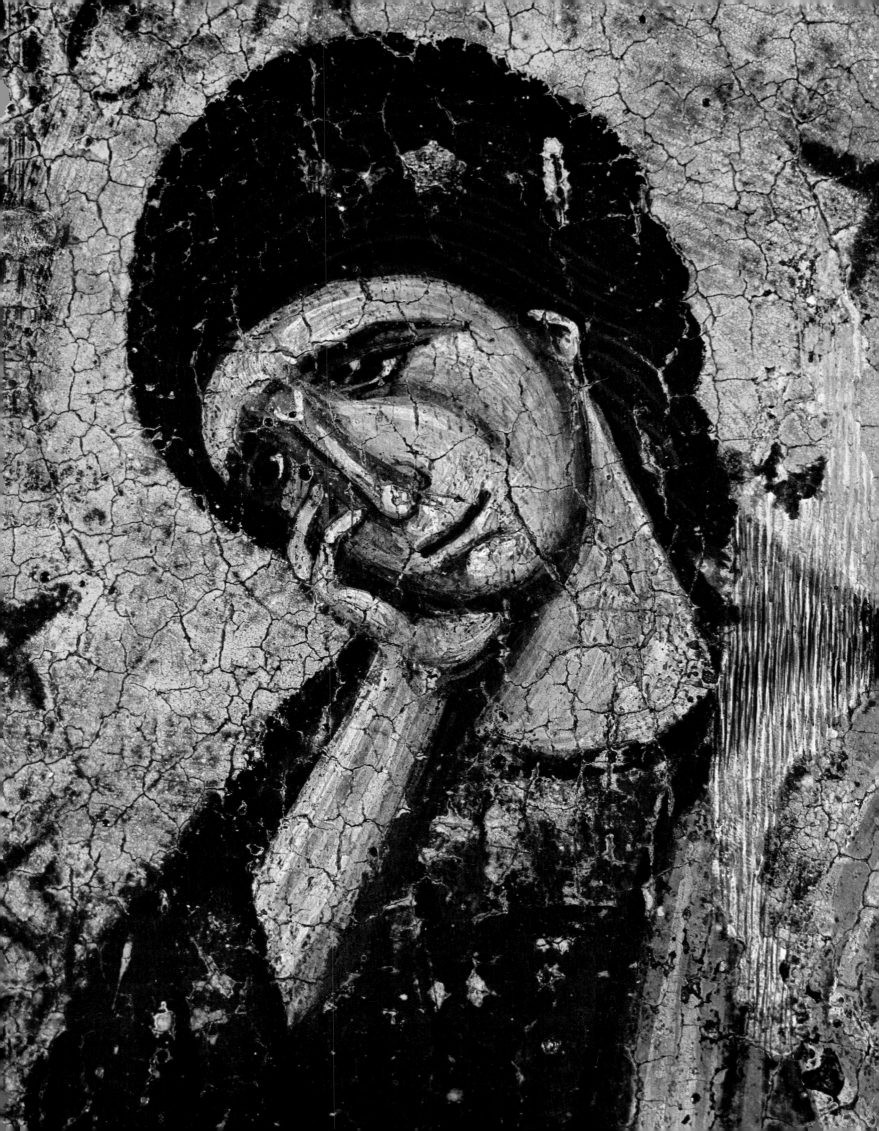

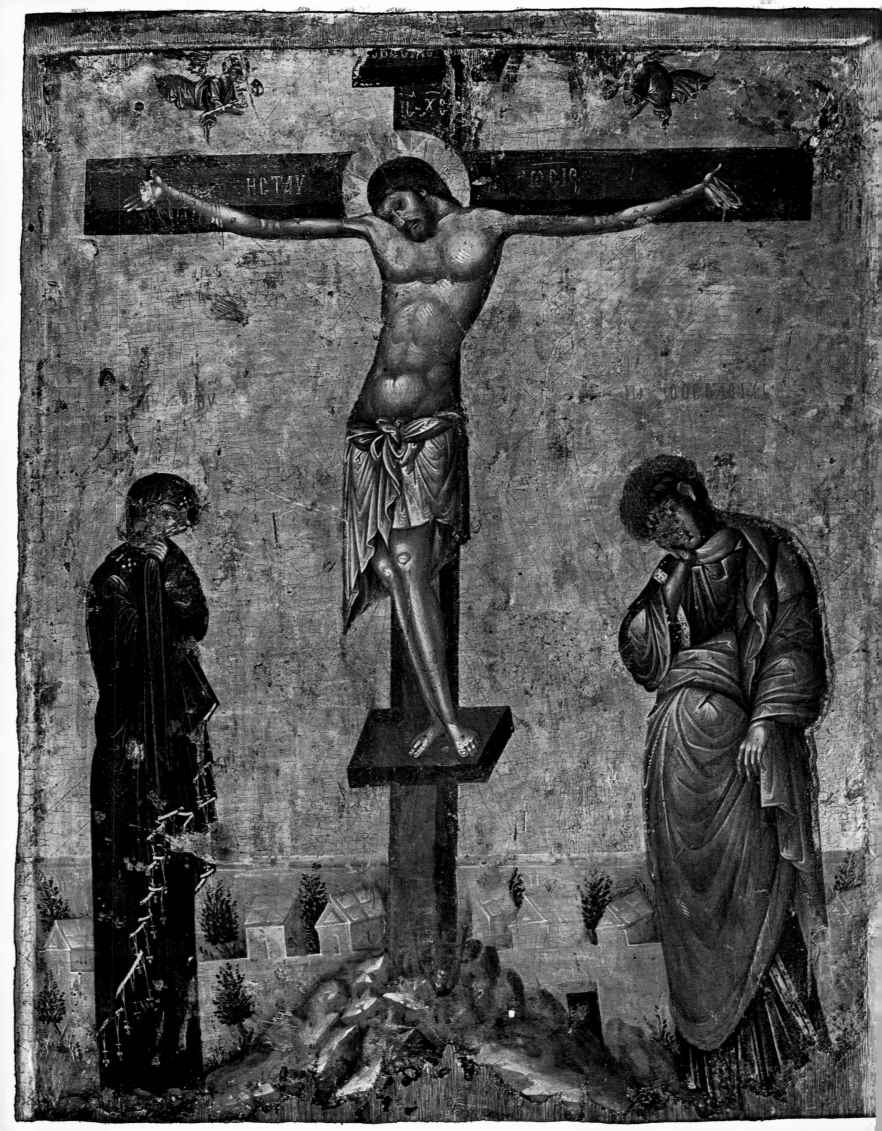

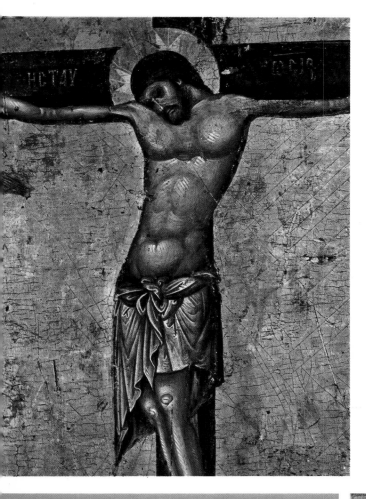

in the early seventh century. The portraits of priests and donors are neither realistic nor impressionistic; they convey only a general idea of an individual, and a strong identification with a remote divine grace.

The church in its representation of Adam and Eve and the Temptation is also rigid and conventional. Yet the image of the Good Shepherd is free and full of movement, and there is such a unity of plan and composition in the whole decorative scheme, including a series of Christ's miracles, that the painter seems to have drawn upon different traditions to symbolize the difference between sin and redemption. The free and illusionistic composition is similar to that of paintings found in the catacombs of Rome, but also to domestic paintings discovered at Pompeii.

The pastoral and elegiac compositions in the second and third century catacombs beneath Rome are the antithesis of the dominant Imperial art. Christians wished to be buried away from their pagan neighbours, so they developed a labyrinth of burial chambers and underground churches on the outskirts of the city. In the first century after Christ only the most important cities, such as Rome and Antioch, had significant Christian communities. Gradually their numbers increased, and from 200 to 300 began to include, not only the urban proletariat, but educated people who made possible the creation of an elite hierarchy of ordained clergy. They drew upon pagan models for their iconography, and the figure of a Greek philosopher, holding a scroll and discoursing amongst his pupils, was adopted to represent Christ as the Word, sitting amongst his disciples. The dead were represented upon the walls and sarcophagi in an *orans* or praying

Crucifixion, School of Constantinople, 120 × 100cm, and details, 14th century

This is a double-sided icon. On the reverse is a Hodegitria type of Virgin and Child. In the icon illustrated Christ hangs dead upon the cross, his head sunk and his eyes shut. He is naked except for a loincloth. The Virgin and St. John the Theologian stand on either side, with their hands and faces held in gestures of grief. There are three inscriptions on the cross – 'The King' (of the Jews), 'Jesus Christ', and 'The Crucifixion'. To the right and left above the cross are small angels. Across the bottom of the icon there is a conventional representation of the walls of Jerusalem. The wide expanse of gold imitates the effect of mosaic, and the elongation of the figures adds to the hieratic atmosphere of the icon. This timelessness is achieved also by the use of only three figures and the rejection of other common narrative details. The crucifixion took place on the hill of Golgotha, 'the place of the skull' (John 19:17) and often the hillock is shown to contain the skull of Adam. This has specific dogmatic meaning. The Crucifixion means not only victory over death, but the redemption of the first Adam by the blood of Christ, who is the new Adam.

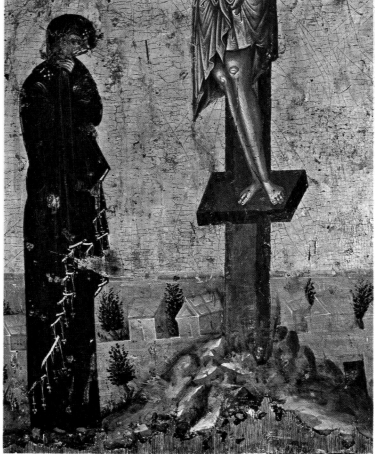

position, and the Christians ornamented the catacombs with scenes of the fall and of salvation, to underscore the redemptive message of Christianity.

The early Christians could ignore the Imperialist art of their contemporaries. With the Edict of Milan, in 313, which established religious tolerance, Christian artists were faced with new problems of scale and content. From pagan cult statuary they had learnt how to articulate space, and the Christian cult of martyrs had influenced them in the veneration of relics, but it was the Imperial attitude towards supreme power that resulted in the veneration of temporal triumphs. Christian artists provided the statues, the icons,

the murals and mosaics celebrating the victories of Byzantine princes, and sanctified, by their use of Christian imagery, the triumph of Christ's Vice-gerent, the emperor. The theme of the emperor's supreme power is found in the mosaics in S. Maria Maggiore in Rome, made for Pope Sixtus III (432–40). In S. Maria Maggiore, the exploits of Abraham and Moses are represented in terms of Roman military art — Abraham appears on a charger, dressed as a Roman general, to meet Melchizedek on foot, bearing bread and wine.

The influence of iconoclasts, or opponents of images, on Christian imagery will be discussed in a later section. But the pagan antecedent for the content of icons is widely evident,

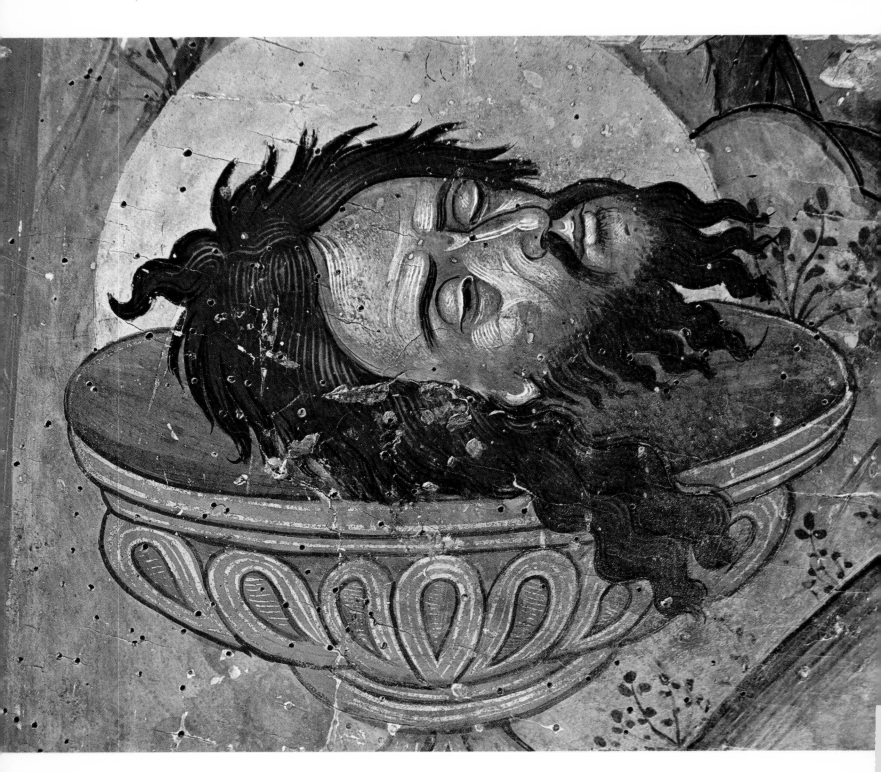

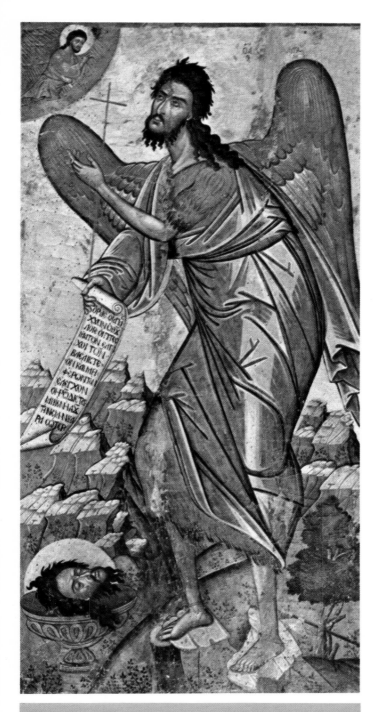

St. John Podrom in the Desert, Greek, 115 × 60cm, and detail, late 17th century

St. John the Baptist is known as St. John Podromos, 'the Forerunner', since he prepared the way for Christ, and suffered martyrdom before him. John is depicted as an angel, since it was prophesied that he would be a messenger (Malachi 3:1), or herald (Matthew 11:10), and also as a man of the desert, an ascetic and preacher of penitence: 'Repent, for the kingdom of Heaven is upon you' (Matthew 3:2), and 'He wears a rough coat of camel's hair' (Matthew 3:4). Christ within the celestial sphere blesses John, who holds an open scroll, which contains a liturgical or biblical text. In his hand is a stick that ends in a cross. He stands among bare rocks in the wilderness of Judaea. To the right lie a tree and an axe – 'Already the axe is laid to the roots of the trees' (Matthew 3:10); to the left is a bowl with the nimbed head of the saint, which recalls his martyrdom.

particularly in the portraits and enthroned gods from Fayum in Egypt. In public places, the Greeks and Romans used to set up portraits of emperors, officials, playwrights and philosophers, and in their homes they hung portraits of their ancestors. In late imperial Egypt, portrait icons, painted in encaustic colours, had been placed on the embalmed bodies of the dead. This tradition of portraiture continued in Constantinople, and reigning emperors paid homage to the portrait of Constantine the Great. In accordance with the cult of the emperor, people worshipped his portrait painted on canvas and wood, and from thence to the veneration of icons was a small step.

Latin Christians intertwined the worship of Mithras, the sun god, with worship of Christ. According to Pope Leo the Great, many Christians climbed the Italian hills in order to worship the sun, and some turned and paid homage to the sun as they climbed the steps of St. Peter's. In the early fifth century, John Chrysostom made reference in one of his homilies to the pagan festival of the sun god:

> On this day also the birthday of Christ was lately fixed at Rome in order that while the heathen were busy with their profane ceremonies the Christians might perform their sacred rites undisturbed. They call this December 25th – the Birthday of the Invincible One (Mithras); but who is so invincible as the Lord? They call it the Birthday of the Solar Disc; but Christ is the sun of righteousness.

Opponents and supporters of icons: Iconoclasts and Iconophiles

For the people of Constantinople, there lay beyond their imperfect and corrupt world another, perfect and incorruptible,

Pages 14–15. *Christ the Divine Wisdom*, School of Salonica, 155 × 99cm, 14th century

Christ blesses with his right hand, and holds a gospel book in his left, open at 'For if you forgive others the wrongs they have done, your heavenly Father will also forgive you' (Matthew 6:14). The inscription reads 'Jesus Christ' and 'The Wisdom of God'. In the *Painter's Manual* by Dionysius of Fourna, (eighteenth century) we read how the blessing hand is represented. 'When you paint the blessing hand do not join the three fingers together but only cross the thumb and the fourth finger: so that the upright finger, that is to say the index finger, and the bent middle finger denote the name IC (Jesus), since the upright finger indicates the I, and the curved one which is next to it, the C. The thumb and fourth finger, which are crossed, with the little finger beside it, denote the name XC (Christ). Since the oblique part of the fourth finger, from where it meets the middle finger, makes the X sign and the little finger, where it is curved, the C. In this way the name XC is shown . . .' This type of Christ commonly appears in the central domes of churches with cupolas, or in the apses of basilicas. It is known as Christ Pantocrator, the Ruler of All.

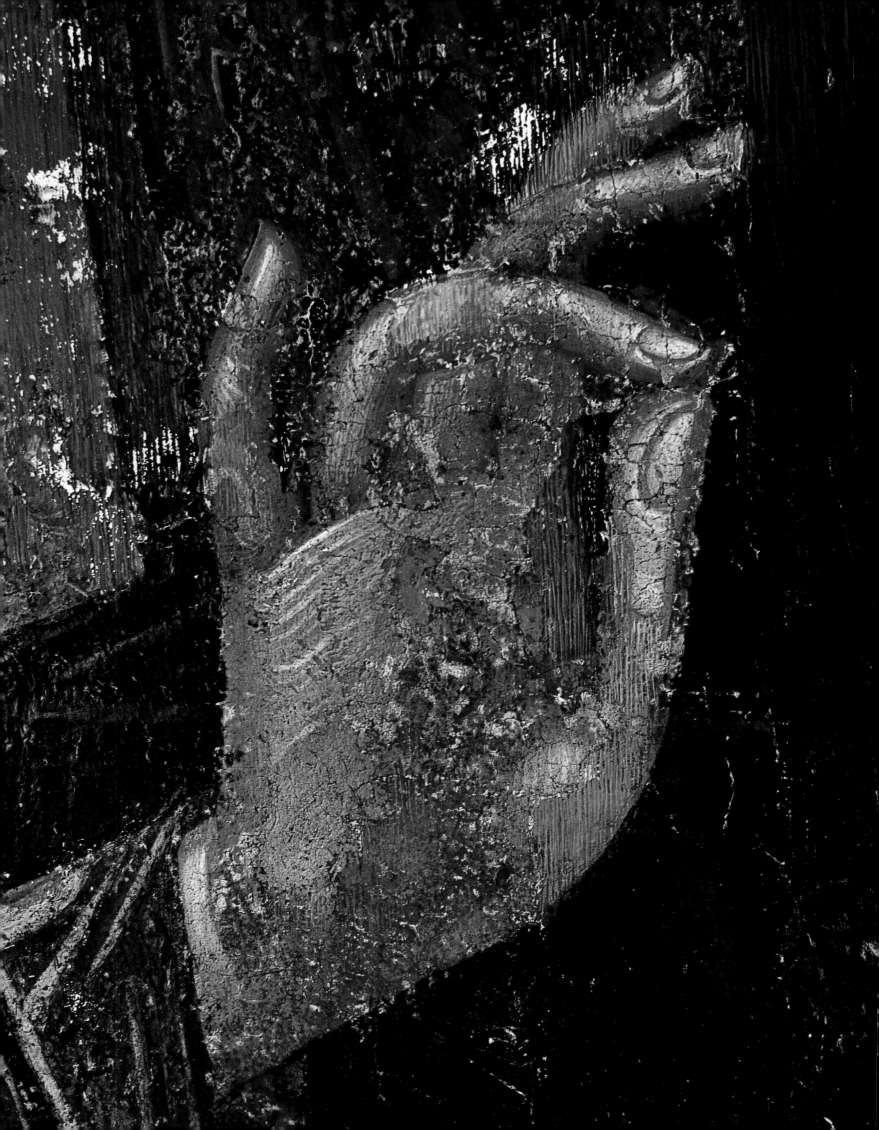

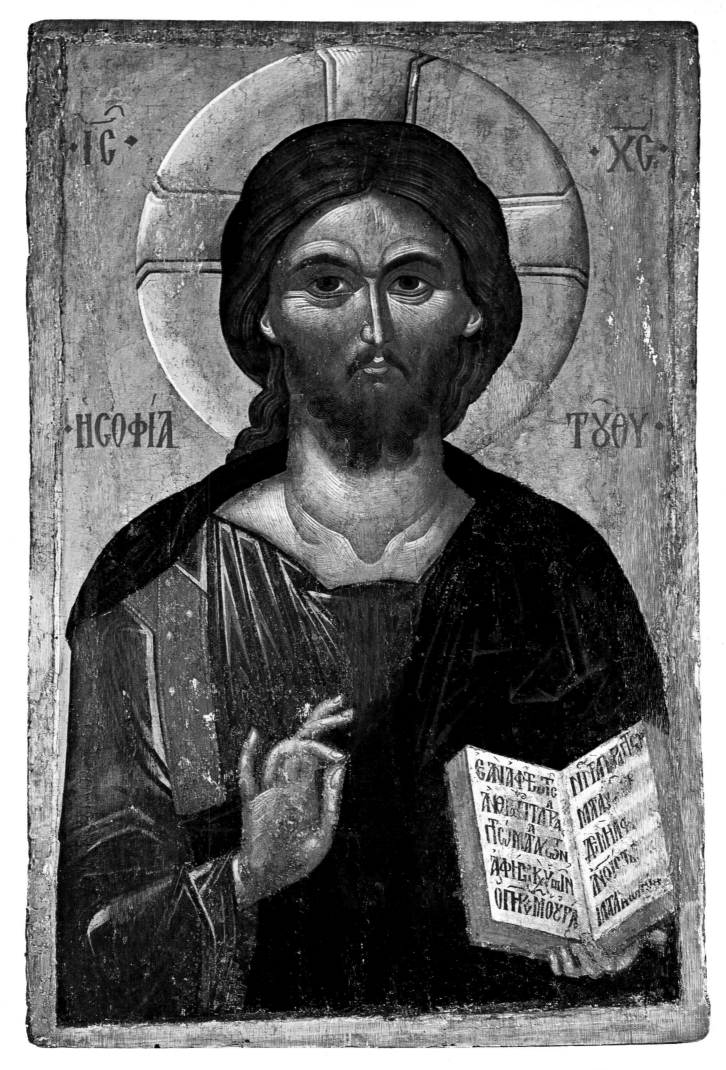

IC̅ XC̅

HCOФIA TŸꞶY

Christ the Divine Wisdom, School of Salonica

15

towards which they must constantly aspire. The state, with all its shortcomings, was, nevertheless, thought to be a model of the ideal state of heaven. Greeks considered that Christ's heaven upon earth ceased outside the boundaries of the Empire. Life on earth was a struggle against unseen forces, both divine and devilish, continuously tempting and never satiated. Unable to reach across the gulf that separated the real world from the ideal, men enlisted as mediators entities which were thought to partake of both earth and heaven: they made use of saints, holy men, relics, and icons.

Each of these entities was a source of miracles, of mercy and guidance. If a man felt himself overcome by unseen forces, or if he fell ill, or his business was faltering, he would turn to such a mediator for its capacity to invoke divine power.

The Christian Empire was vast and contained converts from many different religions. Old Testament prohibitions upon image-worship were not forgotten by the Jews, and for the Bishops, conscious of the pagan ancestry of their flock, this tendency to ascribe miracles to images and relics was alarmingly akin to ancient practices. The distinction between worshipping an icon for what it might represent, or worshipping it for itself; between seeing it as mediator, or as itself a worker of miracles, was too fine to be drawn by any but the highly educated. In 824 the Emperor Michael II complained to Lewis the Pious:

> They not only ask help of the above images, but many hanging linen cloths upon them, placed their children in them as they came out of the font, thus making them baptismal godfathers. . . . Some of the priests and clerks scraped the colours off the images, mixing them with the oblation and wine, and after the celebration of mass, gave of this oblation to those who wished to communicate. Others put the Lord's Body into the hands of the images from which they caused those who wished to communicate to receive it.

From the inception of the Christian State, many people

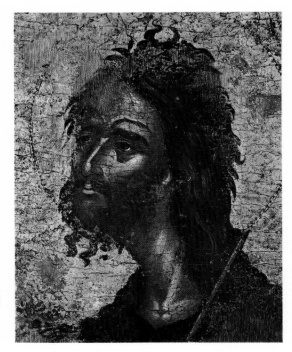

Head of St. John the Baptist, School of Crete, 21·5 × 19cm, 16th century

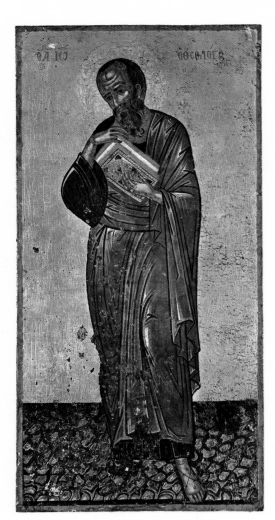

St. John the Theologian, School of Crete, 78·5 × 38·5cm, 16th century

were unhappy about the proliferation of images, and groups of iconoclasts were scattered about the Eastern Empire. However, when the state did move against images, the move was as much a political decision as a religious imperative. Leo III, a general from the mountains of Isauria, in the east, came to power with the support of armies from Anatolia and Armenia, traditionally iconoclast. Their loyalty was vital to him, both to maintain his own power, and to protect the eastern borders of the Empire from Muslim invasion. His aim was not to attack the supremacy of Christ, but to lessen the authority of Christian establishments upon earth.

In 726, Leo III issued an edict banning representations. Subsequently, he moved cautiously towards the destruction of images. His caution did not lessen the impact of the ban. Italy, under Pope Gregory II, repudiated the authority of the Emperor, and in 731 the Italian Church seceded from the Eastern Empire. Gregory armed his people against the Greeks, and when Leo dispatched a punitive force to recall Italy to her allegiance, Italy was ready with arms and allies to defend herself. Statues of Leo were destroyed, tribute withheld, and all the Greek attacks were bloodily defeated. The Emperor's fleet was dispersed by a storm. The main political achievement of the ban on images was to maintain the unity of the Eastern Empire, but to loose control of Italy to powers in Lombardy.

Leo's successor, Constantine V (741–75) imposed the ban

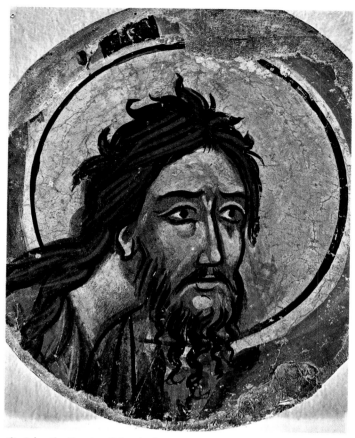

St. John the Baptist, School of Central Greece, 34 × 28cm. 17th century

Head of an Old Ascetic, School of Crete, 34 × 28cm, 1540

more vigorously. In 765 the destruction of images began in earnest, and monasteries, the great refuge of iconophiles, came under attack. Religious houses were secularized, or turned into barracks and inns. The property of the monasteries was confiscated, and monks arrested, imprisoned, and exiled. Some of them died in prison. Others were exhibited in grotesque exhibitions in the Hippodrome — the monks were paraded by the side of harlots, and forced to marry.

After the death of Leo IV in 780 there was a brief respite for the iconophiles during the regency of his wife, the Empress Irene. During her husband's lifetime she could do little, but on her accession to the throne she issued an edict for liberty of conscience, and gradually replaced iconoclast bishops with monks who had retained their love for icons. But the establishment was by now too strongly iconoclast to be soon won over, and the eastern boundaries of the Empire were still protected from Muslim incursions by iconoclast armies. In 786 Irene's council in the Temple of the Holy Apostles, which aimed at restoring images, was broken up by troops, and so she moved the council to Nicaea. In 787, the seventh and last Ecumenical Council restored the worship of images, and Leontius explained the orthodox position to the meeting:

> I, worshipping the image of God, do not worship the material wood and colours, God forbid; but laying hold of the lifeless representation of Christ, I seem myself to lay hold of and to worship Christ through it . . . for the honour of the image passes on to the original and he who worships the image worships in it the person of Him who is therein depicted.

In spite of the intolerance with which Irene treated her opponents, the victory was a fragile one, and iconoclasm was soon reinstated.

In 815, Leo V reaffirmed the tenets of the first council of 754. Leo had observed that while the iconophile emperors had tended to die in exile or in battle, all those emperors who had opposed images had died a natural death while still in power, and had been buried in imperial sepulchres. Leo V drew his own conclusions. A decree of the council of 754 said: 'We declare unanimously, in the name of the Holy Trinity, that there should be rejected and removed and cursed out of the Christian Church every likeness which is made out of any material whatever by the evil art of painters.' The Eucharist was the only true image of Christ. The ascendancy of the iconophiles had been ended by two disastrous defeats inflicted on the Byzantine armies by the Bulgarians in 811 and 813, and with the death of the Bulgarian leader, Krum, in 814, Leo felt secure enough to launch his attack on images. Sacred ornaments were trampled underfoot, liturgical vessels turned to profane use, and churches scraped down and smeared with ashes because they contained holy images.

> And wherever there were venerable images of Christ or the Mother of God, or the saints, these were consigned to the flames or were gouged out or smeared over. If, on the other hand, there were pictures of trees or birds or senseless beasts and, in particular, satanic horse-races, hunts, theatrical and hippodrome scenes, these were preserved with honour and given greater lustre.

According to the *Life* of Stephen the Younger, the Church of the Holy Virgin at Blachernae in Constantinople was not only bereft of its magnificence, but covered in new paintings, and transformed into a 'fruit store and aviary'.

John the Grammarian was particularly zealous in the cause of iconoclasm during this period. In 814 he gained admission to the libraries, and he and his helpers marked those passages amongst the books which favoured iconoclasm. Once images had been condemned by the synod of the following year, they tore holy vestments to shreds, and pictures and illuminated missals were burnt or broken up with axes. The icons were insulted by smearing them with cow dung and foul ointments.

It is to John's influence that late iconophile commentators attribute the iconoclasm of the Emperor Theophilus; John was regarded as a necromancer and magician. After Theophilus' death in 842, however, his wife Theodora, who, like Irene before her, had always been a lover of icons, restored them more permanently. The Muslim threat in the east had abated for a while, the army was less powerful, and the people's superstition triumphed.

Many great works of art were lost during the iconoclast period. Nevertheless, the love of images never lost its hold, as can be seen in the complaint of Michael II, of 824, recorded above. A story is told about 'Roman Mary', an icon sent out to sea by the Patriarch Germanus to save it from destruction by Leo III. It sailed upright for a night and a day until it reached the safety of Rome, where it was rescued from the water, and placed by the Pope in a church dedicated to St.

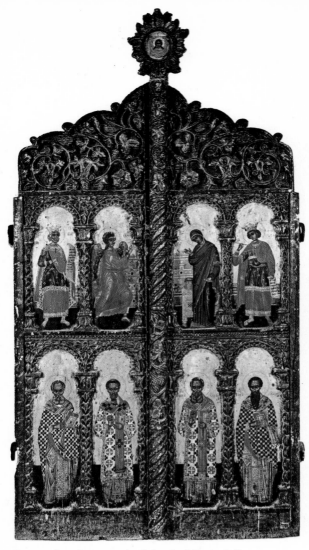

Doors of an Iconostasis, School of Central Greece, 160 × 84cm, 17th century

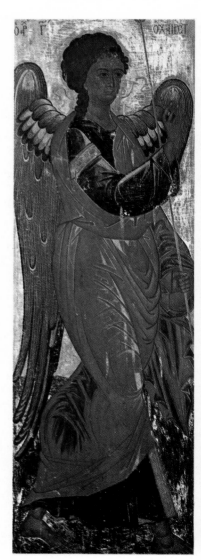

Annunciation, School of Central Greece, 52 × 38cm, 17th century

These two icons come from the two leaves of the central or Royal door of an iconostasis. The scene is described as the Annunciation, and the angel is called 'the Archangel Gabriel', and Mary 'the Mother of God'. The scene illustrates a passage in Luke: 1, 26–38, in which an angel appears to Mary and tells her that she will bear a son whom she will call Jesus. Mary holds a spindle and yarn in her left hand, in accord with details borrowed from the *Protoevangelium* of James, while she holds up her right hand in a gesture of surprise. 'How can this be?' said Mary, 'I am still a Virgin.' The liturgy for the feast of the Annunciation says 'As she heard the words of the archangel so she received in a supernatural manner in her undefiled womb the Son and the Word of God.' Sometimes Mary is shown in a state of fear as the angel rushes in – she turns and drops the yarn. Or she is shown as having accepted the angel's words, and presses her hand to her breast to indicate this. The Annunciation is one scene that has ancient examples. Three Roman catacomb paintings of the fourth century depict the scene, but the angels do not have wings.

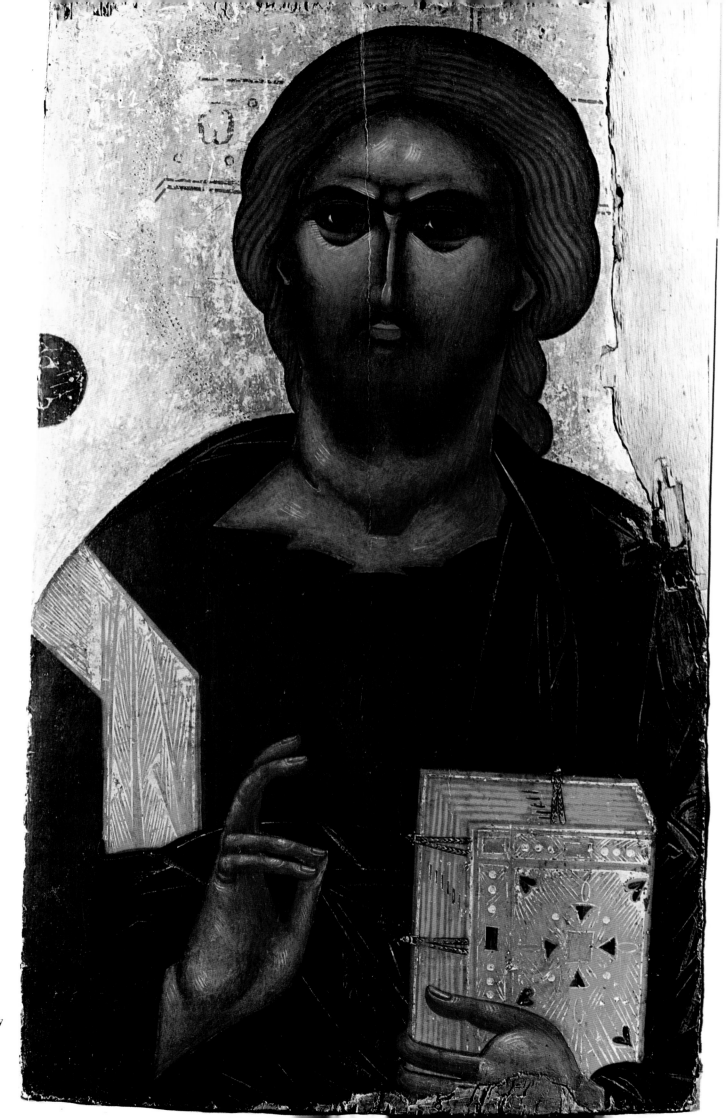

Christat Pantocrator,
Byzantine, 110 ×
66cm, 14th century

Peter. There it remained, safe from harm, until Orthodoxy returned to Constantinople. Then the icon rattled and shook itself from its mountings and made its way down to the Tiber, and thence home to Constantinople.

Like 'Roman Mary', such noble Byzantine ladies as Irene and Theodora concealed their icons until it was thought safe to profess their love for them. Long before Leo III, Constantia, sister of Constantine the Great, had been reproached by Eusebius for asking him to send her an image of Christ. He replied that the 'dignity and glory of God' cannot be painted, and although it would be possible to make an image of the 'mortal flesh', such things are expressly forbidden by the law:

> Once, I do not know how, a woman brought me in her hands a picture of two men in the guise of philosophers, and let fall the statement that they were Paul and the Saviour. I have no means of saying where she had had this from, or learned such a thing. With the view that neither she nor others might be given offence, I took it away from her and kept it in my house, as I thought it improper that such things ever be exhibited to others, lest we appear, like idol worshippers, to carry our God around in an image.

Before she came to power, Theodora hid her icons in her room, and kissed them in secret. The Emperor's jester, free to roam as he liked through the palace, stumbled upon her devotions, and enquired what she was doing. Her answer, that she was playing with dolls, he repeated to the Emperor, who immediately guessed how his wife had been occupied, and angrily taxed her with worshipping icons. This she denied, saying that the jester had seen nothing but the reflections of maids in a mirror. She ordered the jester to say no more about her activities to the Emperor, and thereafter, when he was asked whether Theodora had been playing with her dolls, he would place one hand to his lips, and the other on his behind, saying, 'Quiet, Emperor, don't mention the dolls.'

In spite of the edict of 843, which allowed the worship of icons, there was no great rush to restore the churches to their former glory. People preferred to move cautiously.

The secular role of the icon

The city of Constantinople, new capital of the newly Christian Roman Empire, was dedicated on 11th May, 330. A magnificent procession wound through the streets, bearing the statue reliquary of Constantine Helios. This statue was actually a bronze Apollo, but the pagan head had been replaced by a bust of the Emperor, encircled by the golden rays of the sun, the rays being the nails that had pierced the hands and feet of Christ. It was lifted 117 feet onto eight drums of porphyry, bound in metal, and within its metal sides it concealed a fragment of the True Cross.

In emulation of this majestic precedent, subsequent emperors, on the anniversary of the dedication, had an image

Nativity, S. Sperantzas of Corfu, 37·5 × 30cm, 18th century

This scene is described as 'the Birth of Christ'. From a symbolic representation of the heavenly world emanates a ray, which ends in the star in the cave over the manger. The cave and manger foreshadow the sepulchre. The connection with the Old Testament is made in the ox and the donkey, 'The ox knows its owner and the ass its master's stall (Isaiah 1:3). Mary lies on a mattress, and turns away from the manger in a spirit of lassitude, as if to emphasize the natural birth of the baby. An angel brings good tidings to an astonished shepherd watching over his flock, while many angels watch the three kings from above. These are sometimes named Melchior, Gaspar and Balthasar, and represent the three ages of life. In the right hand corner, the two midwives, whom Joseph brought, bathe the child. They are sometimes named Salome, who stands and pours, and Mea, the wise woman, who sits or crouches. In the left hand corner Joseph sits disconsolate. He is doubtful about the Virgin birth. The old man who confronts him is the devil, who according to tradition tempted him, telling him that such a birth was impossible.

OPPOSITE *Virgin of the Passion*, John Lambardos, School of Crete, 45 × 36cm, 16th–17th century

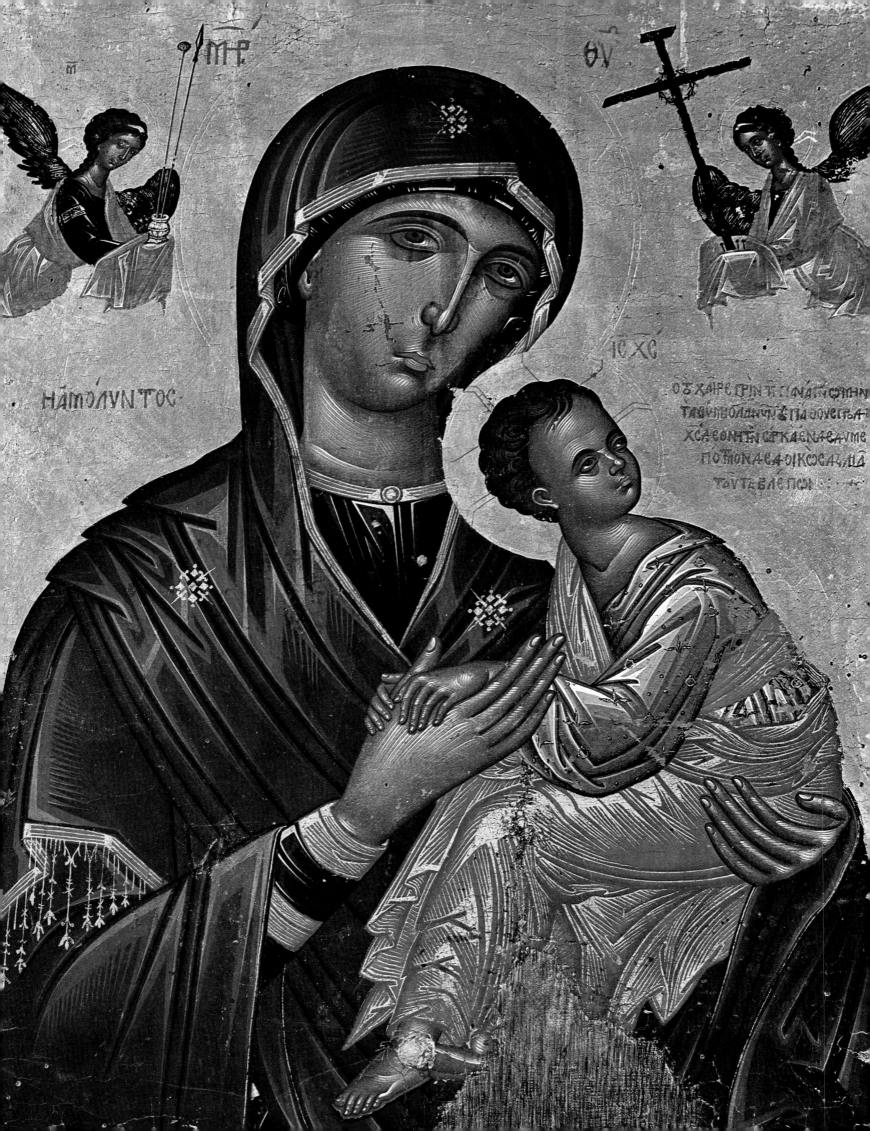

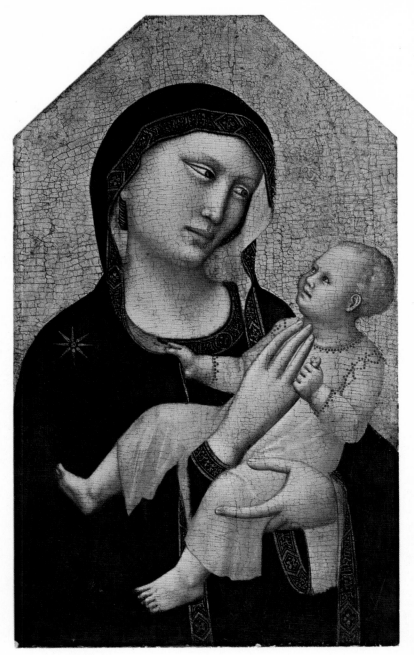

Virgin and Child, Bernardo Daddi, 66 × 39cm, 14th century

Edessa in 544. According to twelfth-century legend, the icon was transferred to Constantinople in 574. In 622, the Emperor Heraclius himself took the icon and showed it to the troops. This was a miraculous icon, made not by the hand of man, but by the print of Christ's face upon a linen cloth; the story of how it was made by Christ himself for King Abgar of Edessa is told in a later section. It was an image of great power, which appeared spontaneously whenever the Christian armies were in peril, and brought them victory.

Another example of the power invested in the image occurred in 626, when Avars and Persians were besieging Constantinople. The Patriarch ordered that icons of the Virgin Mary and Child should be painted on all the western-facing city gates.

> In so doing the Patriarch was, as it were, crying out in spiritual language to the throng of barbarians and to the demons that led them: 'It is against these, O alien nations and demonic tribes, that your war is directed. Your pride and insolence will be crushed by the command of a woman, the Mother of God, whose Son sank the Pharaoh and his whole army in the Red Sea and reduced all demons to impotence.'

The enemy fleet was destroyed in the Golden Horn, and within a year Heraclius had defeated the Persians near Nineveh, made peace in 628, and restored the True Cross to Jerusalem. The image acted in the crusade both as weapon and as sign of the victory soon to be won.

The Byzantines were intensely aware of the correspondences between Old Testament warriors and kings, and Christ himself; the story of Jonah and the whale, for instance, was seen to contain an archetypal resurrection and redemption that was not only Christ's experience and bequest, but also any Christian's hope. What the olive branch meant to Noah, the miraculous icon meant to the waiting troops. The Emperor was the new Moses, holding aloft the cross, more

Virgin of Tenderness, School of Constantinople, 100 × 85cm, 14th century

The type of composition in which the child presses his cheek to his Mother's is first seen in a ninth-century Coptic ivory relief in the Walters Art Gallery, Baltimore, which probably was a model of a well known icon. The earliest panel painting of this type is *Our Lady of Vladimir*, which was taken from Constantinople to Kiev, to the court of the Grand Duke, between 1120 and 1130. In 1153 it was taken to Vladimir. The oldest mosaic icons date from the eleventh century. Many mosaic icons survive in Greece. Large mosaic icons, such as the one in the Patriarchate of Constantinople, are similar in material and technique to wall mosaics of the twelfth century. They would have been intended for marble iconostases. In the thirteenth century, the mosaic technique took on the characteristics of icons, and the tiny stones and small format enabled the artist to display considerable virtuosity. The inscription in red mosaic says 'Mother of God Episkepsis', that is the 'Mother of the Inquiring or Caring God'. This type is also known either as the Virgin Elousa (Virgin of Compassion) or as the Virgin Glykophilousa (Virgin of the Sweet Embrace).

of Constantine the Great carried through the city. Afterwards, emperors would pay it homage.

A portrait of the emperor, usually a painting on canvas or wood, was an accepted object of worship. Hence the icon had a place in the fabric of the Byzantine state from the beginning, and because of the faith people held in its power as mediator, it was seen as protection against the enemy, or as a sign of impending victory, or as an arbiter in purely secular quarrels and lawsuits.

Constantine, after his decisive defeat in 312 of the tyrant Maxentius at the Battle of the Milvian Bridge, related the following story to his biographer Eusebius. Travelling towards Italy, there had appeared before him a dazzling cross, beneath which he saw the words, 'In this, conquer'. Constantine ordered the Christian symbol of the cross to be embroidered upon the clothes of his soldiers, who were indeed victorious.

An exceptional image of Christ is said to have accompanied the Imperial armies against the Persians, notably at

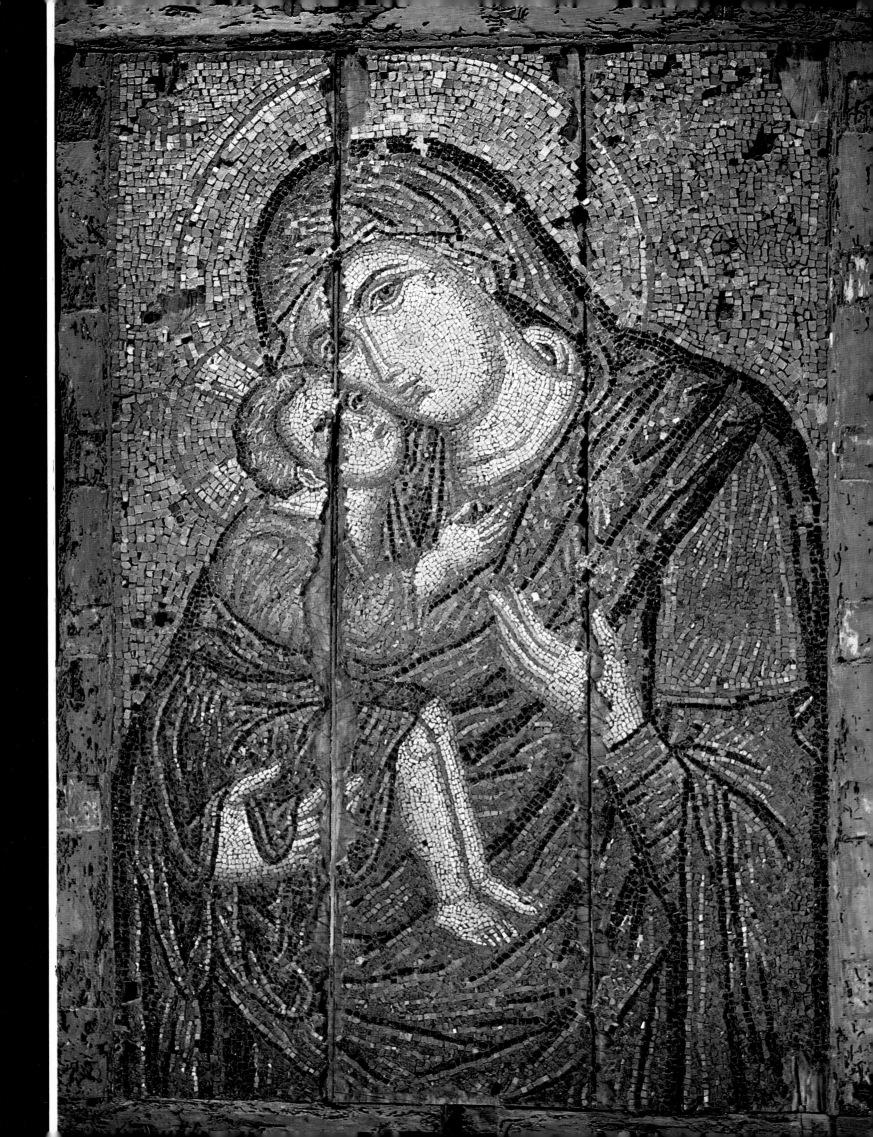

Virgin and Child. School of Constantinople, 105 × 93cm, 14th century

Entry into Jerusalem (detail from *Virgin and Child*)

Dormition of the Virgin (detail from *Virgin and Child*)

potent in war than arms. They rejoiced in the paradox that the wood of cross or icon could conquer the Persian's fire. The 'image-made-without-hands' fulfilled the function of Constantine's cross, or labarum, as Heraclius refought Constantine's wars. Its second return from Edessa was celebrated with the pomp accorded to a great prince, as if Christ were again on earth, and in 944 it was likened to an imperial sceptre. Yet between Heraclius' victories and the tenth century lie more than a hundred years of iconoclasm.

Not all icons, however, had such exalted roles. In 656,

Below *The Prophet Elijah*, School of Crete, 97 × 71 cm, 16th–17th century

Elijah is one of the most formidable Old Testament prophets. He had power to open and close the heavens, and to call forth the fire of the Lord from heaven (1 Kings: 37–38). He was taken alive to heaven in a chariot of fire, and this is regarded as his witnessing, like Moses and the Apostles, the revelation of Christ's divine nature at the Transfiguration. The icon, representing Elijah as 'a hairy man' (2 Kings: 1–8), depicts the scene in which Elijah is told by God to go to the ravine of Kerith, east of the Jordan: 'You shall drink from the stream, and I have commanded ravens to feed you there.' Elijah went and stayed in the ravine, and the ravens bought him bread and meat, morning and evening, and he drank from the stream (1 Kings: 4–6). Elijah turns and contemplates the raven – the rapacious bird has become his servant, by God's will. The meaning of the icon is clearer if we remember the words of St. Basil the Great: 'The Wilderness received the hermit; . . . the provision of his life's journey was hope in God.'

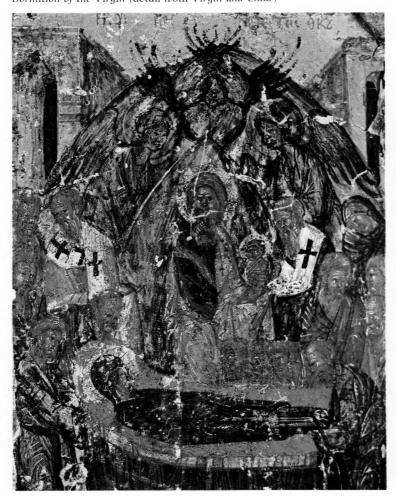

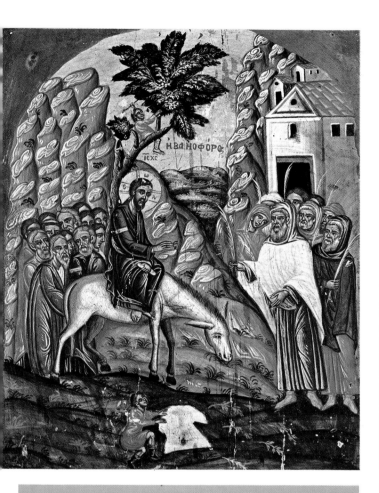

Left *Entry into Jerusalem*, School of Central Greece, 39 × 31cm, 15th–16th century

The Palm Sunday scene shows the arrival in his capital city of Jerusalem of the Messianic King of Israel. Christ makes the triumphal progress of the ruler, prophesied in the Old Testament: 'Rejoice, rejoice daughter of Zion, shout aloud, daughter of Jerusalem; for see, your king is coming to you, his cause won, his victory gained, humble and mounted on an ass . . .' (Zechariah 9:9). In the icon the 'daughter of Zion' is seen among the welcoming citizens. Christ rides sideways, and with his right hand indicates Jerusalem. His halo is crossed and carries the letters *o wv* meaning 'The Being', which reminds the spectator that Christ is the authentic 'image' of the Father, being of the same essence. A child lays a garment under the donkey, as prefigured in the Old Testament (2 Kings 9:13). A child in the tree cuts palms, which were a symbol of courage, and given to conquerors. Jesus has just raised Lazarus from the dead, and will soon win his own victory over death. The gospels do not mention children specifically, only a crowd. The children come into the story later, after the sellers were chased from the temple. This addition comes from the Acts of Pilate, which says, 'The children of the Hebrews held palms in their hands'.

Right *St. John the Theologian*, from the Greek Islands, 43 × 33cm, 17th–18th century

The two figures are seated inside a cave on the Isle of Patmos. St. John the Theologian turns and listens to the voice of God emanating from a 'glory'. He dictates his gospel to his pupil Prochorus, who writes 'In the beginning'. Between them is an eagle with a halo, which is the symbol of the Evangelist, John. On the table are a number of scrolls in a box. Dionysius of Fourna describes the scene more fully: 'St. John the Divine and Evangelist, seated in a cave; he looks behind him up to heaven in ecstasy, with his right hand on his knees and his left hand stretched out to Prochorus. St. Prochorus is seated before him and writes "In the beginning was the word, and the word was with God, and the Word was God." In front of them are tetramorphs, winged beasts, holding Gospels and looking at them. That of Matthew is in the form of a man, that of Mark in the form of a lion, that of Luke in the form of an ox, and that of John in the form of an eagle. The one in the likeness of a man signifies the flesh. That in the likeness of a lion characterizes strength and royalty. That in the likeness of an ox denotes sacrificial priesthood. That in the likeness of an eagle indicates the descent of the Holy Spirit. Know this, that Matthew, Mark and Luke are represented inside houses, whenever they are writing, while John is shown in the cave with Prochorus.'

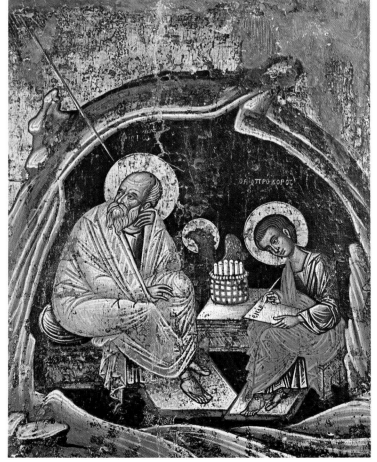

ABOVE LEFT AND RIGHT *St. John the Theologian* (details), School of the Greek Islands

RIGHT *Virgin and Child*, School of Salonica, 85 × 65cm, 14th century

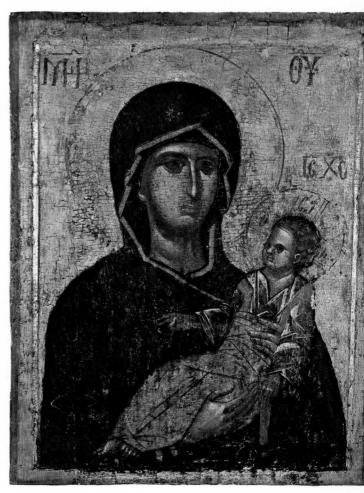

when a theological dispute ended in agreement between Maximus Confessor and Theodosius, Bishop of Caesarea, the Gospel book and the icons of Christ and the Virgin were kissed by the disputants, as acknowledgement of their part in effecting conciliation. Michael Psellus (1018?–78) tells of a similar worldly use of an icon, this time the miraculous Icon of the Virgin at the Church of the Blachernae in Constantinople. It was usual practice to cover some sacred icons with veils. Every Friday the veil of this icon was lifted by divine power, as a symbol of the Mother of God's longing to make the whole world 'a sanctuary and an inviolable refuge'. A general and a group of monks decided to use this miraculous event in order to settle their differences over the water rights to a certain mill. If the veil rose, the general would be deemed to be in the right. At first the veil lay still, and the general prepared to relinquish his claim. At last it lifted. Both sides then claimed victory, but the Emperor intervened and judged in favour of the general.

Although the Virgin gave no clear sign, the icon allowed a judgement to be made which was acceptable since it was divinely inspired; the icon was seen as a direct link with heavenly powers. The holy man also was seen as a mediator with heaven, because of his flight from society and his mortification of the flesh. His detachment from the affairs of society made him an appropriate person to settle disputes. In the *Life* of St. Daniel the Stylite, we read of one of these holy men chosen by the crowd to resolve an argument. A Goth who presumed to mock the holy man from a window,

Six Saints, School of Constantinople, 98 × 52cm, 14th–15th century

In the top register, from left to right, the saints are St. George, St. Demetrius, and St. Panteleimon. In the lower register from left to right, the saints are St. Theodore the Stratelate (the General), St. Theodore Tyro (the Recruit) and St. Anthony. St. Demetrius of Thessalonika was killed during the reign of the Emperor Maximian, and, as the legend grew, he was represented as a warrior saint. He is one of the most famous Eastern saints. St. Panteleimon was doctor to the Emperor Maximian at Nicomedia, and he treated the sick and the poor without payment. In the icon he wears the loose clothes of his profession. He was martyred in about 305. During his death agony he was tied to an olive tree, which miraculously burst into fruit. St. Theodore the General appears in the ninth century in the Pontus, on the Black Sea coast of Turkey. He is identical with St. Theodore the Recruit, who was a young soldier in the Roman Army who set fire to the Temple of Cybele in about 306 in Euchaita in Pontus. For this act, he was burned alive in a furnace. St. Anthony is the father of asceticism. He died in 355 at the age of 105. He lived in an abandoned fort near the Nile for twenty years, on a diet of bread and water. Later he withdrew further to a place near the Red Sea, where he grew his own wheat. He wears a cowl, and carries a scroll, which says, 'I saw the snares of the devil laid out upon the ground.' This script, though in a slightly different form, appears in another icon of St. Anthony by Michael Damaskinos.

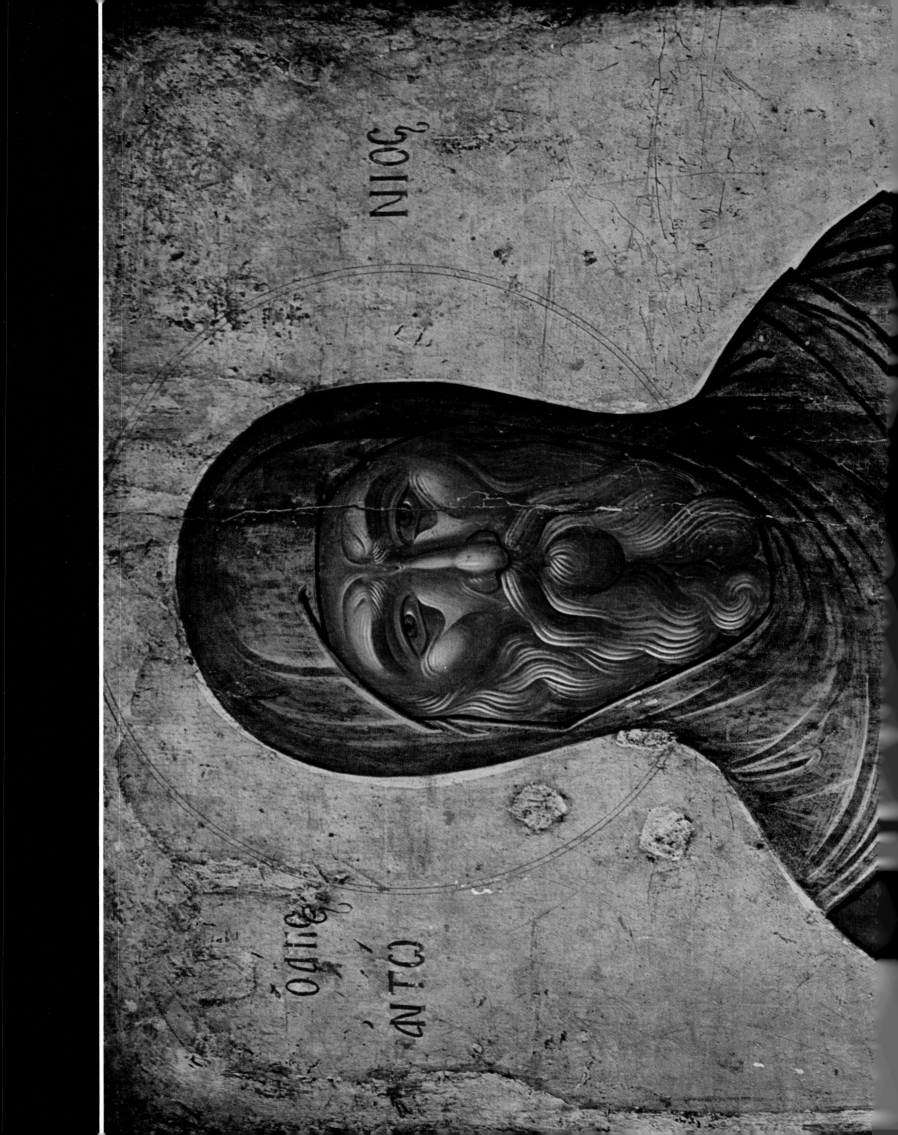

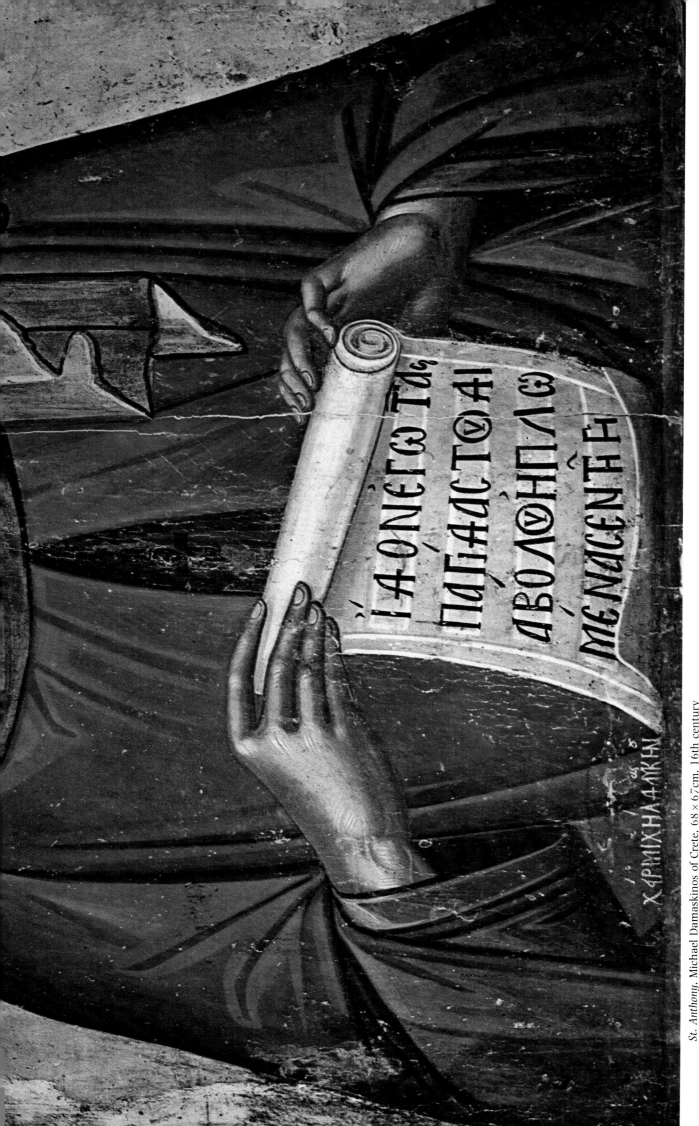

St. Anthony. Michael Damaskinos of Crete. 68 × 67cm. 16th century

by calling out, 'See, here is our new consul', was punished by being 'hurled down from the height by the power of God, and burst asunder'. And yet his observation was not wide of the mark; the holy man remained a stranger, and yet participated in the affairs of State.

The relics of dead saints were also supposed to possess this power of mediation, and when any saint died there was a great demand for relics. An iconoclast satire speaks of the ten hands of the martyr Procopius, the fifteen jaws of Theodore, the four heads of St. George. The corpse of St. Daniel the Stylite was protected by a coffin of lead from being dismantled by those anxious for relics. But first, the people demanded to see the body of their saint, so the plank to which his body was tied was stood upright, 'and thus, like an icon, the holy man was displayed to all on every side: and for many hours the people all looked at him and also with cries and tears besought him to be an advocate with God on behalf of them all.'

By contemplating the image, praying before it, and lighting candles, the people encouraged their icons to intercede for them. Images of Simeon Stylites were set up in workshops as a protection to the workers. Opponents of icons told of a figure of Christ, over a gate of the Imperial Palace, which was known as 'the surety', since it had stood surety to a sailor for a series of debts contracted with a Jewish money-lender.

The power of the icons to intercede with God for Byzantium failed at last, however, and the hopeless procession of

Nativity, Russian, 34·5 × 27cm, 16th century

icons and relics about the walls of Constantinople, besieged by Turks in 1453, was unable to save the city from destruction.

Symbolism, Platonism, and magic

As the controversy raged between those who were for images and those who were against, the acceptability of symbols varied according to which party was in favour. The theologian apologists decided that 'the honour shown to the image is conveyed to its prototype' whereas the people who condemned icons held that 'where images are set up, the customs of the pagans do the rest'.

In spite of the Judaic Old Testament prohibition of images, there had always been currents of thought which accepted the representation of human beings. Eusebius wrote in the

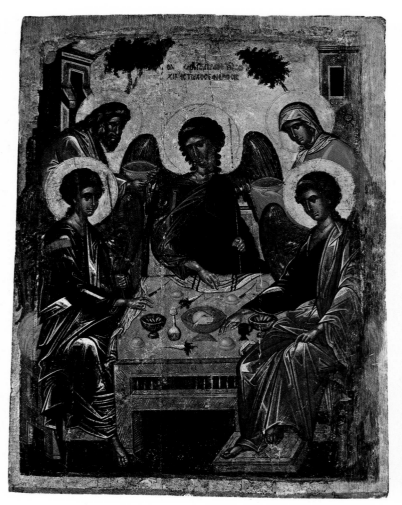

Hospitality of Abraham, School of Crete, 72 × 57cm, 16th century

Three angels sit at a table, and are waited on by Abraham and Sarah. The scene is based on the passage from Genesis 18:1, in which the Lord is reported to have appeared before Abraham in the Grove of Mamre, in the form of three men. On the table are radishes, bread, and the head of the lamb prepared by Abraham. The table is a type of altar, with the vessels of the eucharist upon it. St. Cyril of Alexandria imagined this story to be the revelation of the Trinity to man in the embodiment of the three angelic messengers.

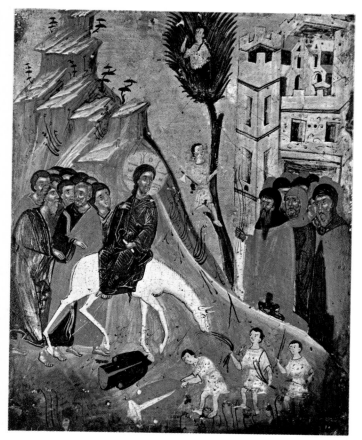

Entry into Jerusalem. School of Central Greece. 52 × 38cm.
17th century

it was upon this aspiration that the iconophiles based their arguments. The Synod 'in Trullo' was the first known statement of an official position on religious imagery, and the first attempt to correct ancient abuses, 'errors' of the Jews or of the Latins, since the lamb was rare in the Eastern Church. The desire of the Bishops that Christ appear in human form, however, was repudiated in 726, when Leo III issued his ban on images, and the theologians mustered their arguments and confronted one another.

The appeal of the icon to the philosophers lay in the form of mystical Platonism of which it partook. The painter strove to depict, not the actual world, but the perfect world which lay beyond it. The icon is sufficiently like its prototype in the perfect world, or heaven, to act as a conveyor of grace, but it is essentially different, since the prototype belongs to heaven, and the image to earth. The icon must depict the other-worldliness of its subject, and it achieves this by the self-suppression of the artist, which results in an extremely conservative and dematerialized style and in remote expression on the faces. Nevertheless, the icon belongs to the real world; 'Surely the image is not in all respects similar to its prototype, for the image is one thing and the subject another, and there is necessarily a difference between them.'

This difference reflects the truth of Christ becoming man. The relation of the icon to the prototype is the same as that of Christ to God the Father. John of Damascus (c. 676–754),

Crucifixion. School of Crete. 101 × 82cm. 16th century

fourth century. 'I have seen a great many portraits of the Saviour, of Peter and of Paul, which have been preserved up to our present times.' Gnostic sects placed pictures of Christ beside those of Pythagoras, Plato and Aristotle. In the third century, the Emperor Alexander Severus obtained an effigy of Christ, which he placed in his chapel among the portraits of Apollonius, Abraham, and Orpheus. Nevertheless, it was the impact of the ban which caused the permanent use of early Christian symbols.

The Good Shepherd was extensively used in early times as a sign for Christ, but rarely after the eighth century. Christ was also represented as a lamb, particularly in the West, and often appears in catacombs. Its use partly springs from references in the Old Testament, partly from the passage in St. John's Gospel: 'The next day he saw Jesus coming towards him, and said, "Behold, the Lamb of God, who takes away the sin of the world"' (John 1 : 29). Gradually, the stigmata came to be represented upon the sides and feet of the lamb; this happened towards the end of the sixth century, and after that date it is usually shown bearing a cross, symbolic of the Passion. In 692, however, the Synod held in Constantinople 'in Trullo' which means in a domed building, denied the need for such symbolism. Canon 82 said:

> In order that the perfect should be set down before everybody's eyes even in painting, we decree that [the figure of] the Lamb, Christ our God, who removes the sins of the world, should henceforward be set up in human form on images also, in the place of the ancient lamb.

It was 'the perfect' that painting aimed to represent, and

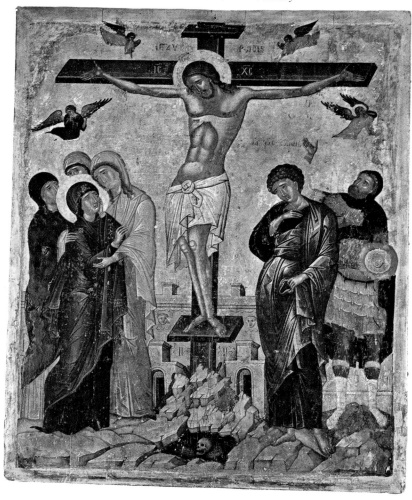

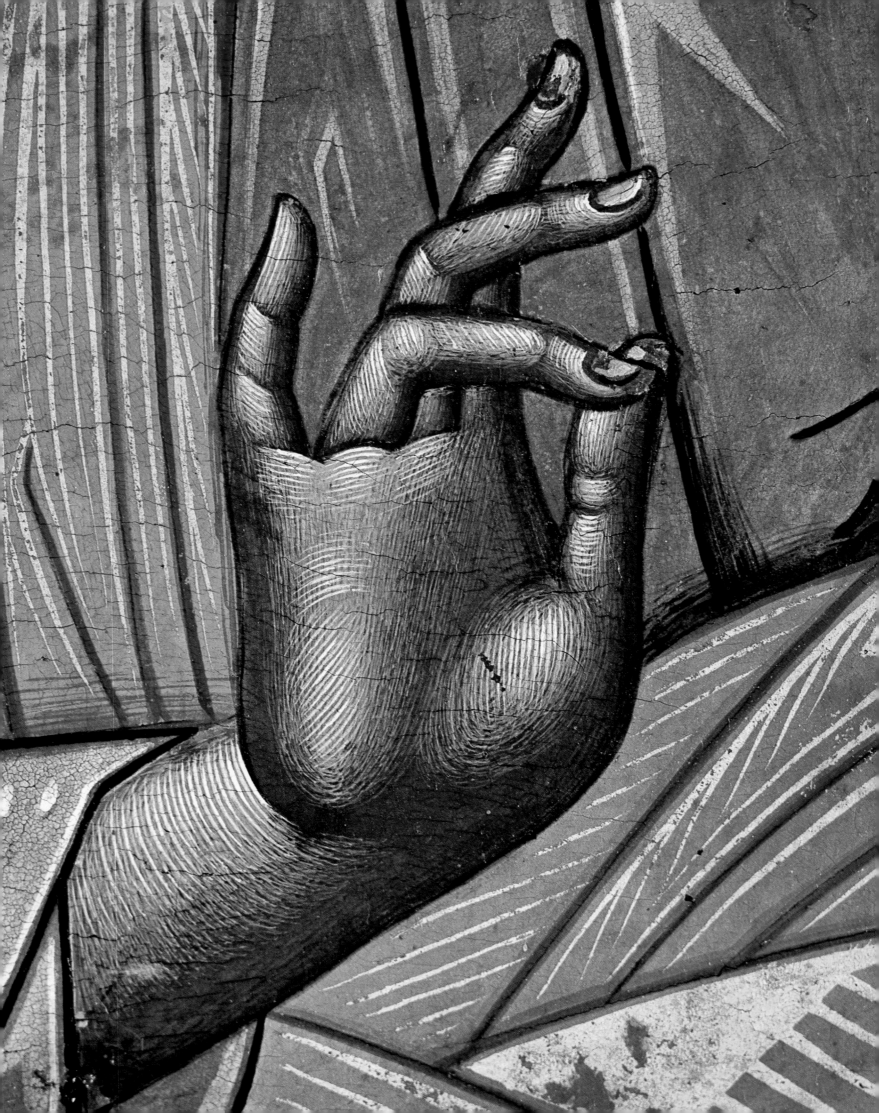

Christ Enthroned. Emmanuel Tzanes of Crete. 106 × 66cm. 1664

in his essays on holy images, justifies the icon because of the doctrine of the Incarnation. In 530, Dionysius the Areopagite said, 'Sensible images do indeed show forth invisible things.'

For the less sophisticated, however, it was easy to lose the sense of icon as link or intercessor, and to imbue the painting itself with magical powers. The distinction was also lost both in the case of relics, and in the people's attitude to holy men, and miraculous stories sprang up all over the empire.

Likeness in portraiture was considered important, and there might have been insuperable difficulties in obtaining true likenesses of Christ, the Apostles, and the Holy Family. But the problems of the artist were overcome by miraculous intervention, and later Christians could see the objects of their devotion in the 'image made-without-hands'. There is a tradition that one of the first icons had been made by Christ himself, a tradition contained in the *History* of Evagrius, written at the end of the sixth century. It concerns a king of Edessa, now Urfa in Turkey, whose name was King Abgar. This king suffered from leprosy, and having heard of the healing power of Christ in desperation sent his ambassador Ananias to Palestine. Such was the crowd surrounding Christ, however, that Ananias was unable to force his way towards him, and had to content himself with sketching his features from a distance. Christ knew of the ambassador's presence, however, and when He had finished preaching, soaked a piece of linen in water and pressed the wet cloth to his face. He gave the resulting impression to Ananias, promising to send one of his disciples to Edessa

OPPOSITE *Christ Enthroned* (detail)

after his ascension. Abgar was cured of leprosy by the 'icon made-without-hands', and Edessa became the first Christian state. This 'mandilion', and two miraculous impressions on bricks (*keramidia*) were regarded as direct material testimonies of the Word Incarnate.

The miraculous image that appeared from heaven had its own tradition in the pagan world. It is recorded in the New Testament that Ephesus is temple keeper of the great Artemis, and of the sacred stone that fell from the sky (Acts 19:35). Many cities boasted of statues of gods sent directly from heaven. The Palladium of Troy was an image of Pallas Minerva said to have fallen from heaven. The story of King Abgar's mandilion adds another dimension to the heathen tradition, as it is an occasion of God become man.

Other artists were helped in their struggles towards perfection by divine intervention. St. Nicon Metanoeites, who lived in the tenth century, was said to have appeared in spirit before the painter, who, never having seen the saint, was unable to make a proper likeness. The apparition caused the features of the saint to be imprinted upon the panel.

For the people of Byzantium it was often the icon itself, not the prototype, that wrought miracles, and many, such as 'Roman Mary', were personalized to a fantastic degree. One man, wishing to fasten a rope, attached it with a nail to the head of an image of St. Peter. Immediately the man was overcome with terrible pain in his head, which ceased only when the nail was removed.

Another story is told of an icon of the Virgin, made in Jerusalem, which, bought by a monk for a Sardinian nun, had performed several miracles. The icon exuded oil, and this was used by the nun for healing. On one occasion, she asked a priest to move the icon for her, and, in spite of his fear of it, the priest attempted to do so. However, he approached it without due care, his hand withered, and within three days he was dead. Undaunted, the nun herself placed the icon in the chosen niche, whereupon there grew from it breasts of flesh, and below these the painting also took on the qualities of flesh, from which the healing oil continued to

Christ Pantocrator, Emmanuel Tzanes of Crete. 92·5 × 69cm. 1680

drip. Some of this was given to pilgrims by the monks, and the Sultan of Damascus was cured of blindness by it. The oil became fleshy, and exuded blood.

Such stories were frequent during the iconoclast controversy; in 726 the Patriarch of Constantinople spoke of the painted hand of the Virgin, from which balsam flowed. Indeed, it was often sufficient merely to know the dimensions of the subject in the revered image, the measurements of which could then be inscribed onto a small tablet and worn around the neck on a piece of string, of magical length. It was the practice of pilgrims in Jerusalem to measure the length of the limbs in representations of Christ, and carefully to preserve the numbers on a tablet as a link with divine power.

Another icon of the Virgin Mary was the one supposed to have been painted from life by St. Luke. Having secured the Virgin's blessing on the painting, St. Luke despatched it to Antioch, from where it was sent to Constantinople, and eventually housed in a monastery. By custom this icon was displayed at the Imperial palace during the Easter Festival, and the sanctity of its painter preserved it from the fury of the iconoclasts.

Monks and relics

Both holy men and relics acquired the quality that belonged to icons; they were considered to be mediators

Crucifixion and Stories of the Passion, Italian, 247 × 200cm, 12th century

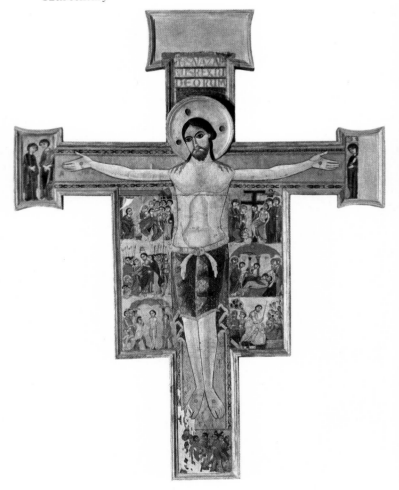

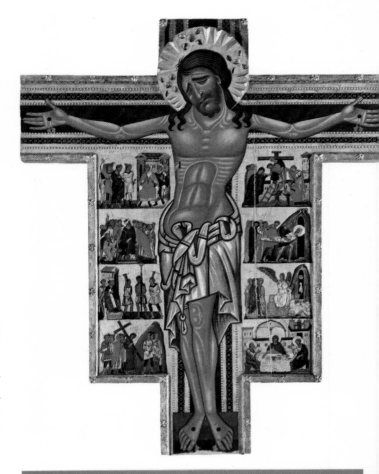

Crucifix with Stories of the Passion, School of Pisa, 277 × 231 cm, and detail, 12th century

In this detail, there are three scenes: the Deposition from the cross, the Entombment, and the women, bearing spices, at the tomb. In the Deposition, Joseph of Arimethaea stands on a ladder and holds Christ's body from behind, gently lowering it. Nicodemus kneels down and with pliers loosens the lower nails. The image is derived directly from the Crucifixion scene – Mary and John stand in their traditional places on either side of the schematic hill of Golgotha, outside the walls of Jerusalem. Mary raises her veiled hands, and presses the hand of the dead Christ against her cheek. Three holy women stand to one side as mourners. The four women are in the next scene, the Entombment, with John. Joseph and Nicodemus carry the body wrapped in a winding sheet. The earliest instances of this scene date from the second half of the ninth century in marginal psalters; for example, the Chludov Psalter has a miniature of the Entombment illustrating Psalm 88:6, 'Thou hast plunged me into the lowest abyss, in dark places, in the depths.' The third scene uses different parts of the gospels. From Matthew come the guards who 'lay like the dead' (Matthew 28:4). From Mark come the three women, and the one youth 'wearing a white robe' indicating the empty tomb. And from John comes Simon Peter's vision of the empty tomb: 'He saw the linen wrappings lying, and the napkin, which had been over his head, not lying with the wrappings but rolled together in a place by itself' (John 20:7).

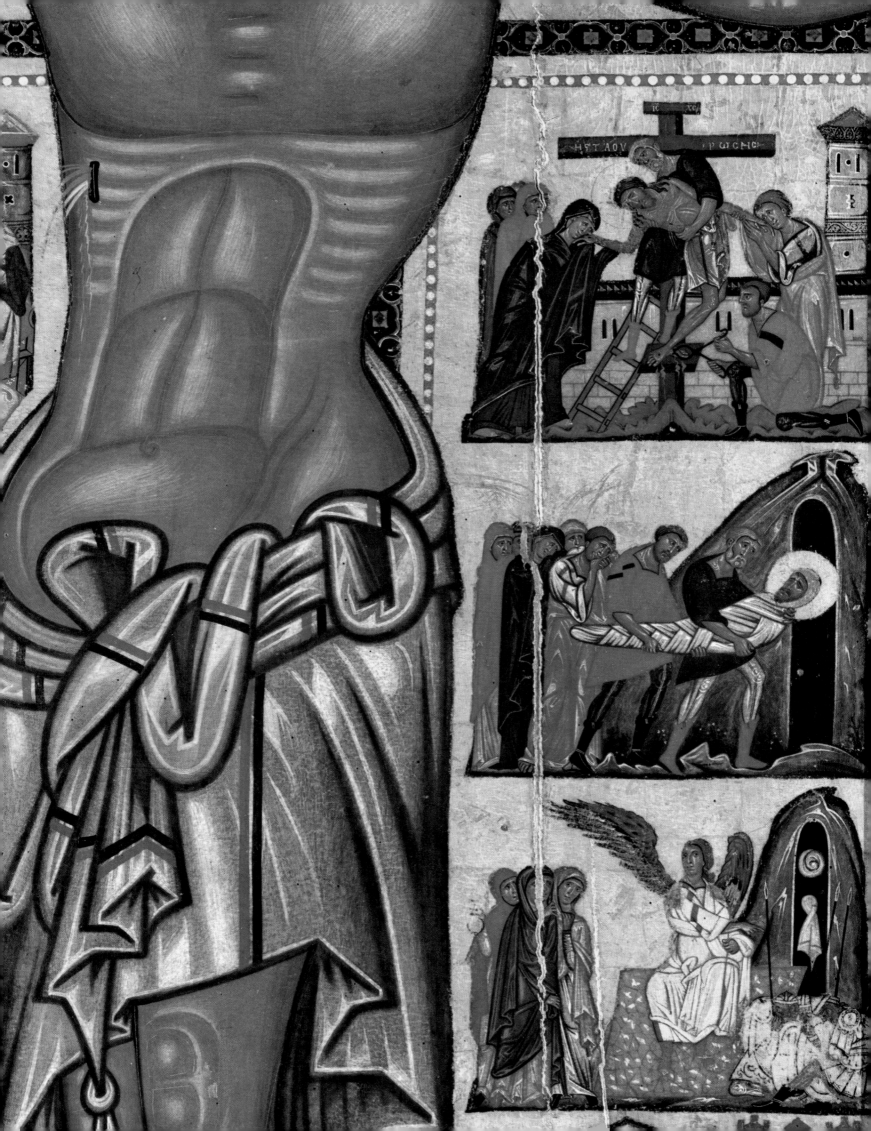

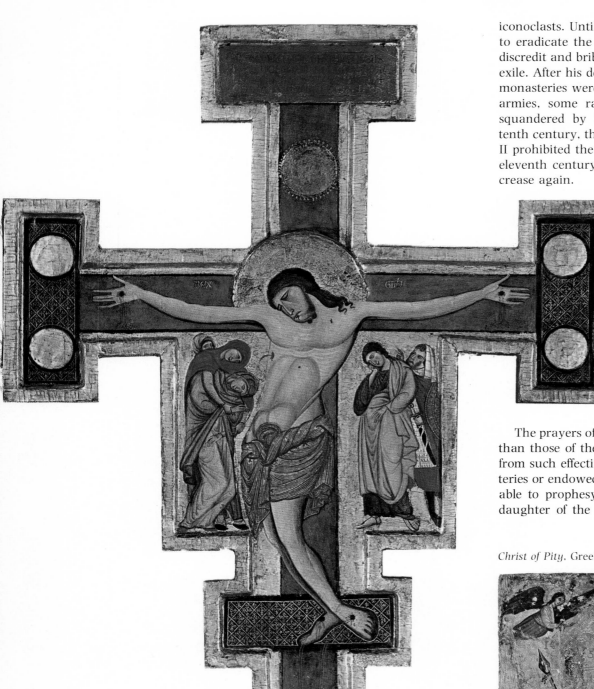

iconoclasts. Until his death in 775 Constantine had striven to eradicate the monasteries. He went to great lengths to discredit and bribe them, or persecute them by execution or exile. After his death, the attrition continued; some eastern monasteries were abandoned because of assaults by enemy armies, some ran out of money or had their benefices squandered by lay managers. In Constantinople, in the tenth century, the emperors Nicephoros II Phocas and Basil II prohibited the establishment of new monasteries. By the eleventh century, however, the numbers had begun to increase again.

Crucifixion, Master of St. Francis.
92 × 70cm

The prayers of the monk were supposed to be more potent than those of the layman, and it was in hope of benefiting from such effective prayer that people founded new monasteries or endowed old ones. It was thought that monks were able to prophesy, and to raise the dead. Anna Comnena, daughter of the Emperor Alexius I, was sceptical of these

Christ of Pity. Greek. 36 × 32cm. 17th century

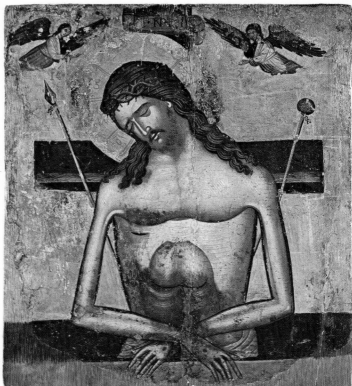

between heaven and earth. And with them, too, the people tended to lose sight of the difference between the mediator and the power behind it, and gradually the power was invested in the mediator. There were many more monks than holy men or hermits, and they formed a sizeable proportion of the population. They are important for a number of reasons, not the least being their function as painters of icons. However, earthly monkish power had declined with the loss of land and property under Constantine V and the

A Prophet (detail), School of Crete

Pages 40–1. *St. George with Scenes from his Life*, School of Cyprus, 109 × 72cm, 13th century

There is doubt about the provenance of this icon. Work in high relief is common in the West, and the costume, as well as the division of the shield into four fields, are Western in character. However, the inscription, around the border of the shield in pseudo-cufic script, might indicate that the place of origin was the Muslim East.

St. George, in three-quarter view in high relief, points towards Christ in heaven. In the bottom left hand corner, the donor kneels in supplication. Above stand two angels holding a piece of cloth. On the margins of the icon are twelve scenes from the saint's life. St. George, brought before the Emperor Diocletian, was tortured for his faith, but he performed various miracles while he was in prison. For example, a farmer named Glicherius visited him, complaining that his ox had just died. St. George said, 'Go on your way, your ox is alive', which the farmer, returning home, found to be true. St. George was forced by Diocletian's magus, Athanasius, to drink poison, but it did not affect him. He said that his God would not only preserve life, but restore it, and, to the astonishment of the emperor and his magician, St. George raised a man from the dead. Other stories connect St. George with King Dadynos, the idolater. The conception of St. George as a cavalier saint in conflict with a monster is a confusion of a later tradition with St. Theodore and the dragon of Euchatus. The later story tells how St. George rescued the son and the daughter of Dadynos from the dragon.

Daniel in the Lions' Den, School of Constantinople, 28 × 23cm, 14th century

The *orans* figure of the prophet Daniel turns towards his left. From that direction an angel carries Habakkuk, who brings a pitcher of water to Daniel. Dionysius of Fourna describes a version of the scene thus: 'Daniel is in the midst of a dark pit, with his face and hands upraised; he is surrounded by seven lions. Above him the Archangel Michael holds the prophet Habakkuk by the hair of his head; Habakkuk has a basket of bread and cooked food, which he gives to Daniel.' Daniel in the den was used to illustrate the words of Psalm 39, 'He has thrown me into the deadly den', in a manuscript in the Vatican, made in 1059. However, the tenor of the psalm also suggests a different saint who had a similar incident in his life, so the Theodore Psalter in the British Museum, London, made in 1066, shows Gregory the Illuminator of Armenia being hauled out of a hole into which he has been thrown, and then conducting the converted royal family to church.

St. George with Scenes from his Life. School of Cyprus(?)

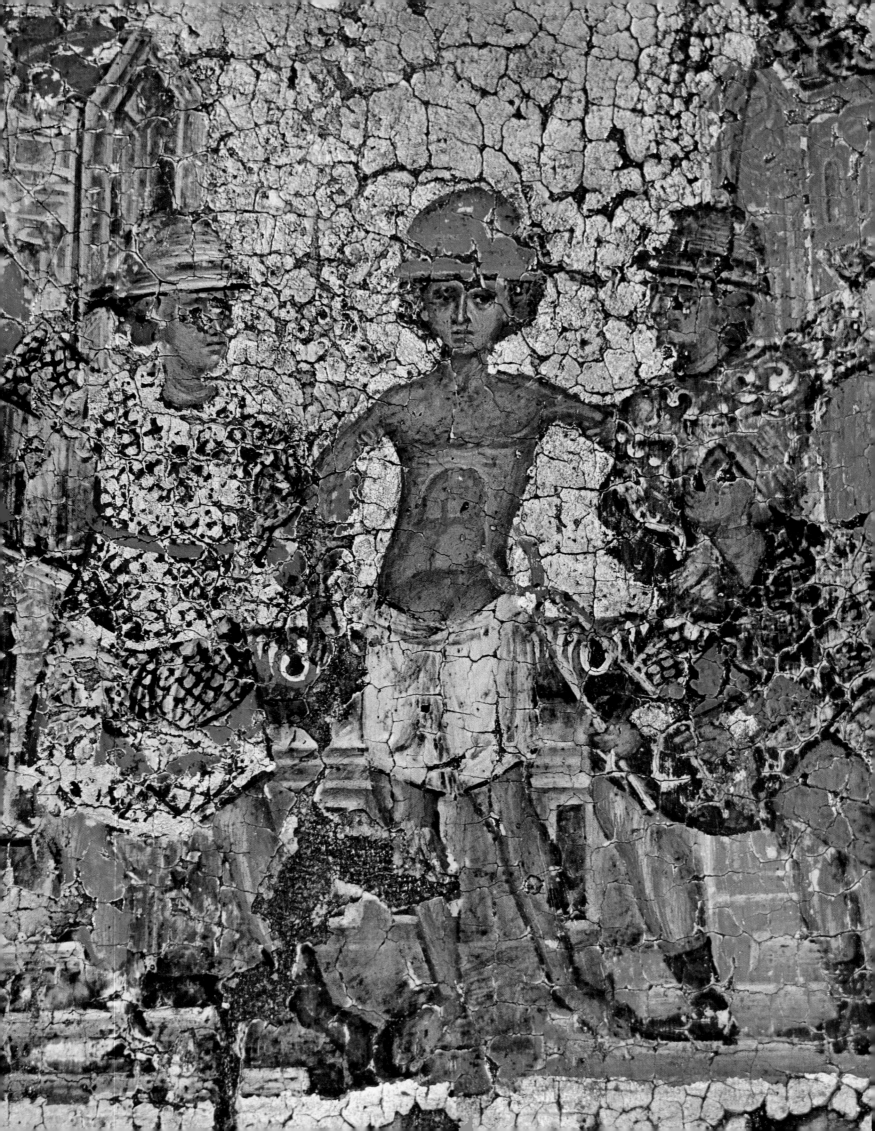

stories; she pointed out in her biography of her father that the emperor himself was unable to perform the miracles that Christ had performed, and thought it likely that the miraculous monks were fakes. Michael Psellus, chief professor of philosophy in Constantinople, poured scorn on the monkish claims. He recommended, however, that the claims of magic should be closely studied, and argued that belief in the supernatural arose from ignorance about those laws of nature that rule the universe. He wrote a popular book on demonology, in which he described elaborate ceremonies used to procure the meeting of demons with people, and he carefully defined and classified the different varieties of demon. According to him, the science of demonology had often interested Christians, who formed cults based on magic rites in the hope of achieving a glimpse of the Almighty.

When a saint died, there was always a great clamour for relics of the dead man. The relics were placed in costly and beautiful reliquaries, and placed in the churches of the empire. Pilgrims made pious journeys to visit these relics, and great things were expected of them in the way of miracles.

LEFT *An Angel* (detail of *Virgin of the Passion*), John Lambardos, 16th–17th century

FAR LEFT *St. George's Imprisonment* (detail from *St. George, with Scenes from his Life*)

BELOW *An Angel* (detail from *St. George, with Scenes from his Life*)

Below *Portrait of St. George*, School of Constantinople, 75 × 50cm, 15th century

The warrior saint is shown frontally in half length. His right hand holds a javelin, forming a diagonal across the picture, and his left hand holds an embossed buckler. His head is elegantly formed, with long regular features, surrounded by short brown hair, and a halo. The highlights around the eyes, the modelling of the cheeks and neck, recall another icon in this book, that of *Archangel Michael* from the School of Constantinople. Both are excellent examples of the work carried out under the Palaeologian dynasty of emperors after Constantinople was regained by the Greeks in 1261. However, the seeds of such refined and hieratic expressions may be seen outside the capital in the twelfth century, notably in the church in Nerezi, Yugoslavia, completed in 1164, in the fresco of St. Panteleimon after whom the church is named.

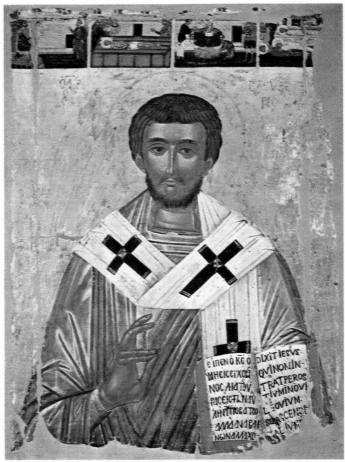

St. Eleuthere, School of Crete, 105 × 72cm, 16th century

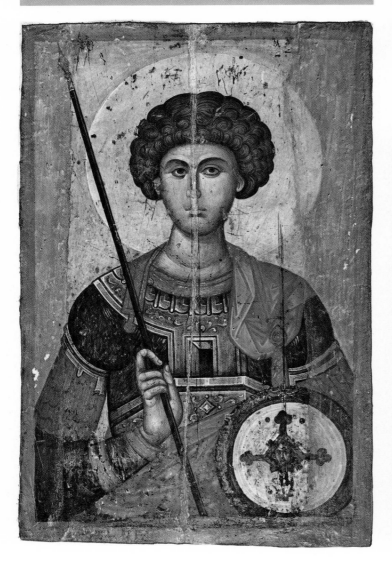

Right *St. Catherine*, Victor of Crete, 120 × 85cm, 17th century

St. Catherine of Alexandria is shown, in the rich garments of a queen, seated at a desk, upon which is an open book. Other books and a celestial sphere are at her feet. Her left hand rests upon the wheel, which is an emblem of the torture she suffered. She holds in the same hand a crucifix, and the palm of a martyr. St. Catherine succeeded to the throne when she was fourteen years old, but shut herself up in the palace, devoting herself to the study of philosophy. She resisted all entreaties to marry, until a hermit gave her a picture of the Virgin Mary and Jesus, from which time she devoted herself to Christ, forsaking her books, her spheres and her philosophers. In a vision she saw herself betrothed to Christ, and she withdrew further from the world. The tyrant Maxentius came to Alexandria, and commanded the Christians to renounce their faith. When Catherine defeated his philosophers in argument, and converted them to Christianity, Maxentius had them executed. He ordered that Catherine should be torn to pieces between two wheels, but fire from heaven destroyed the machine. Finally, Catherine was beheaded. St. Catherine is the patron saint of philosophers, saddlers, spinsters, students, and ropemakers.

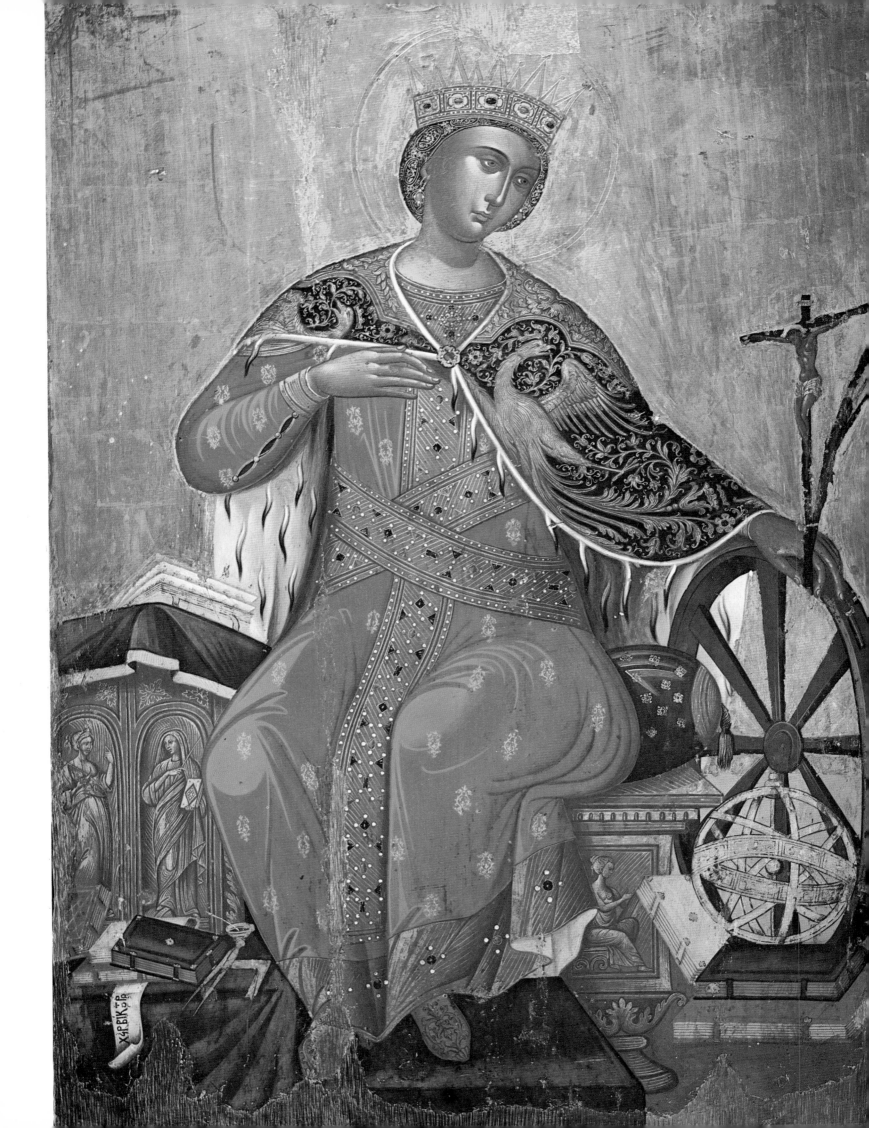

A Russian pilgrim named Anthony of Novgorod visited Constantinople in 1200, and described the Church of St. Sophia, and the relics he saw there:

> We first worshipped St. Sophia, kissing the two slabs of the Lord's sepulchre. Furthermore we saw the seals, and the figure of the Mother of God, nursing Christ. This image a Jew at Jerusalem pierced in the neck with a knife, and blood flowed forth. The blood of the image, all dried up, we saw in the smaller sanctuary. In the sanctuary of St. Sophia is the blood of the holy martyr Pantaleon with milk, placed in a reliquary like a little branch or bough, yet without their having mixed. Besides that, there is his head, and the head of the Apostle Quadratus, and many relics of other saints: the heads of Hermolaus and Stratonicus, the arm of Germanos, which is laid on those who are to be ordained Patriarchs; the image of the Virgin which Germanos sent in a boat to Rome by sea; and the small marble table on which Christ celebrated His Supper with the disciples, as well as His swaddling clothes and the golden Vessels, which the Magi brought with their offerings.

By the time Anthony of Novgorod saw these, and many other marvels, in St. Sophia, the Fourth Crusade was already mooted, and by 1203 the soldiers were encamped outside Constantinople. Daunted by the prospect of the great journey

St. Paraskeva, Russian, 79 × 67cm, and detail, 15th century

St. Paraskeva stands in an *orans* posture, holding a scroll in her left hand. Two angels place the crown of martyrdom on her head, and she is dressed in red, another allusion to her martyrdom, and in white as a symbol of chastity. Each picture is accompanied by a great deal of script, as if the artist had used a *Life* of the saint as the source for his painting. St. Paraskeva is an invented saint, but she was supposed to have lived in the middle of the second century, and to have been beheaded at the command of the Emperor Antoninus. After the death of her parents she became a nun, travelled to Italy, and preached Christianity in Rome. There she quarrelled with the Emperor, and was whipped and thrown into prison. She was led to her trial in chains, and on the way passed a group of idols, which fell down and shattered. The icon illustrates how she was chained to a column and slashed with knives, tortured with a saw, and torn with hot irons. In some stories she was condemned to be eaten by a dragon, but made the sign of the cross, which caused it to burst. Finally, she was beheaded, and we see her burial. Her name means 'Friday', and she is remembered on Good Friday, as well as being the patroness of women and of markets.

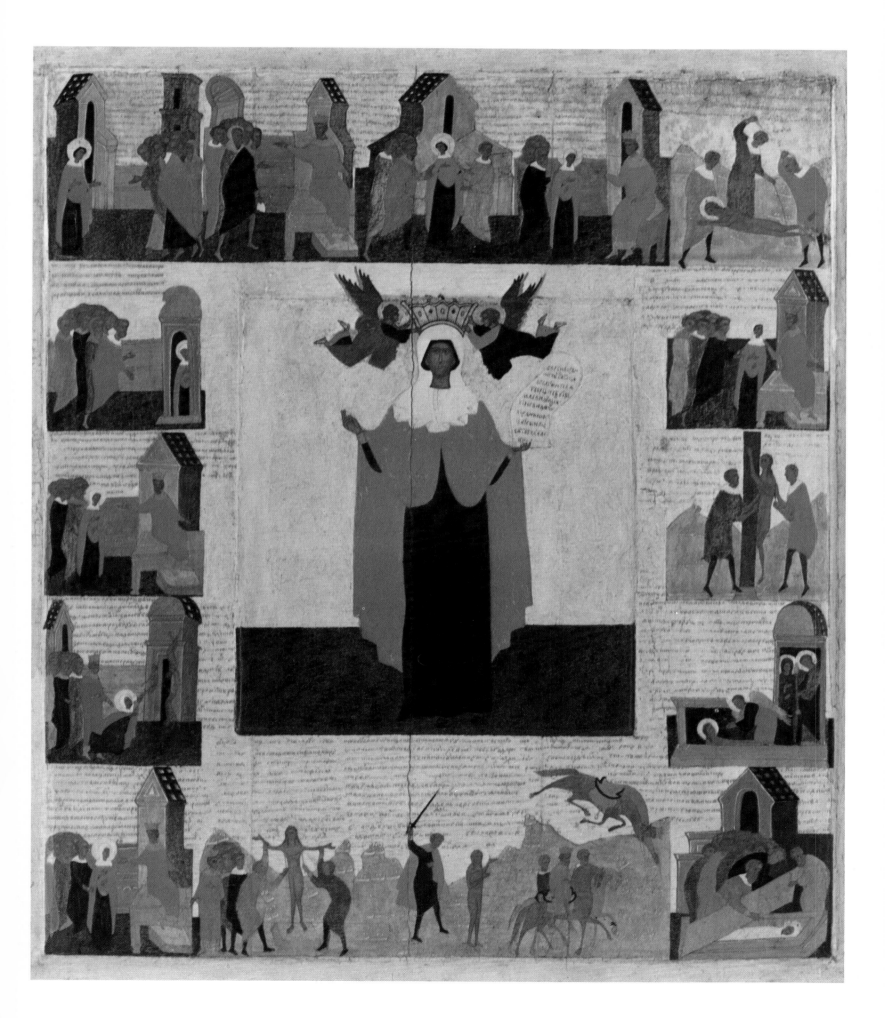

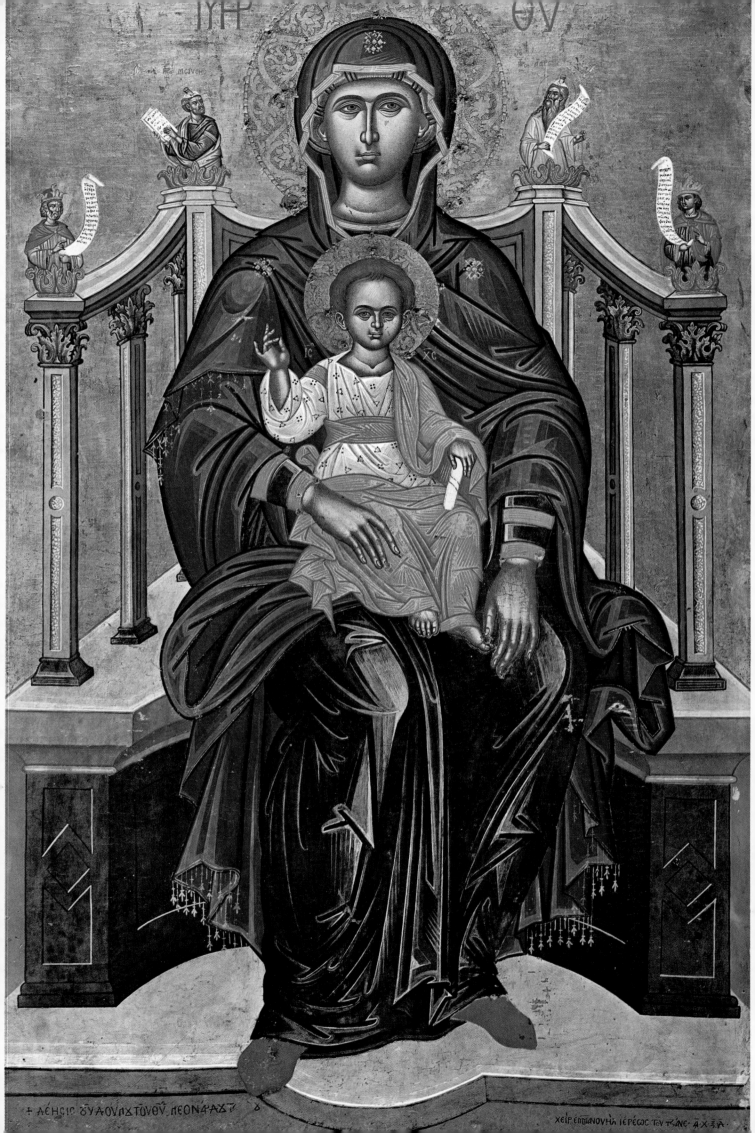

Virgin of Tenderness. School of the Greek Islands. 43 × 34cm. 17th century

BELOW *Virgin of Tenderness* (detail)

Virgin Suckling. Makarios of Galatista. 100 × 71cm. 18th century

to Jerusalem, the Latin army preferred the easier prey of Constantinople, riven with dynastic quarrels. In 1204 the Latins stormed the city, and ransacked it for its incomparable treasures, destroying much of what they could not carry away. The Greek royal families fled into Asia Minor.

Love and the Sirens. unknown artist. 51 × 67cm. 1825

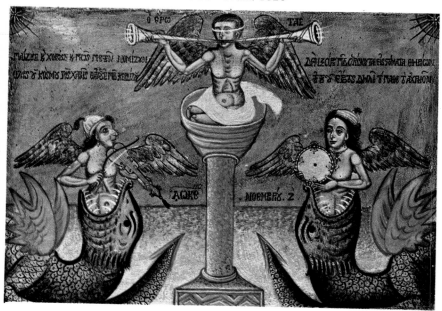

OPPOSITE *Virgin and Child*. Emmanuel Tzanes of Crete. 106 × 66cm. 1664

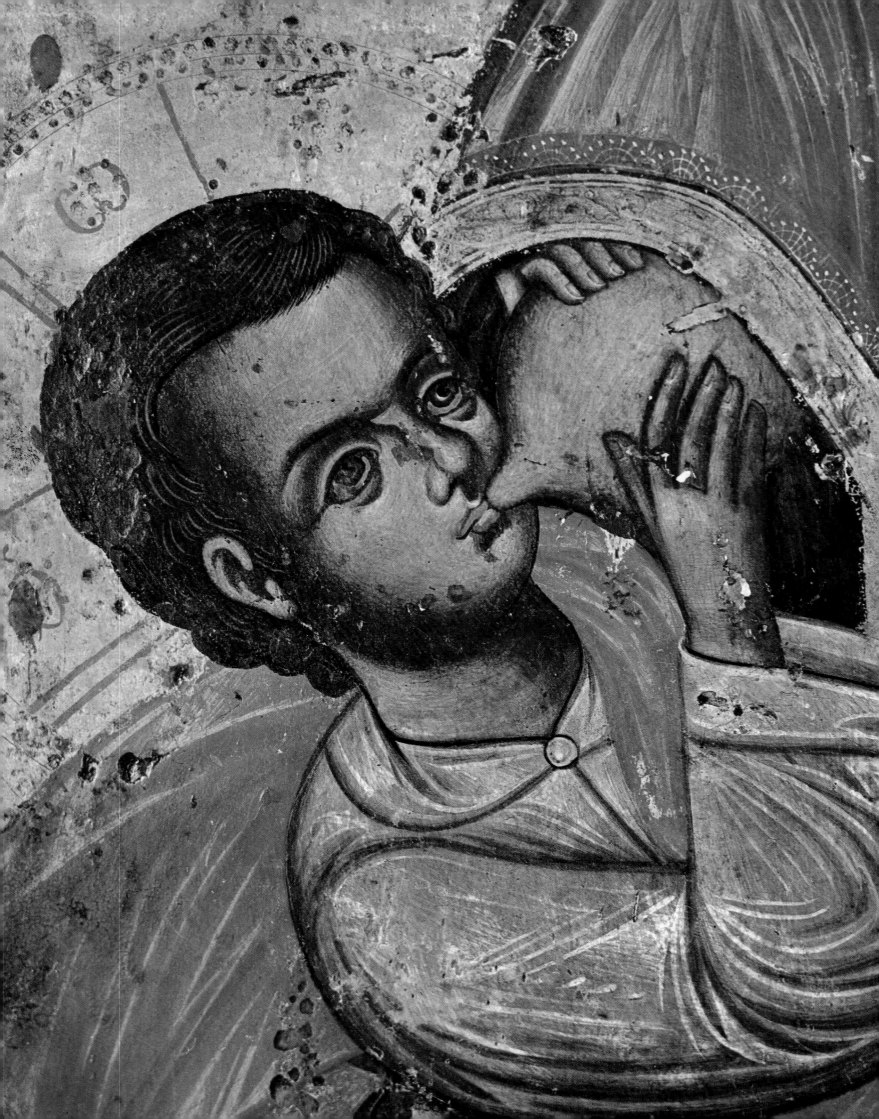

setting up rival kingdoms at Trebizond and Nicaea. From Nicaea, in 1261, Michael VIII Palaeologus reconquered Constantinople, much impoverished, and instigated a re-markable renaissance in the arts. Of this renaissance, the Church of St. Saviour in Chora (Kariye Camii), in Istanbul, is the most impressive monument. But the Palaeologues could not check the inexorable decline. The Empire dwindled in size over the years until it comprised little more than the city-state of Constantinople itself. The Western Empire failed to unite against the Turks, and the city fell in 1453. The second Rome was lost, and the centre of Orthodoxy moved to Moscow, the third Rome.

'He Rejoices in Thee', Greek, 65 × 55cm, 15th century

OPPOSITE *'He Rejoices in Thee'* (detail)

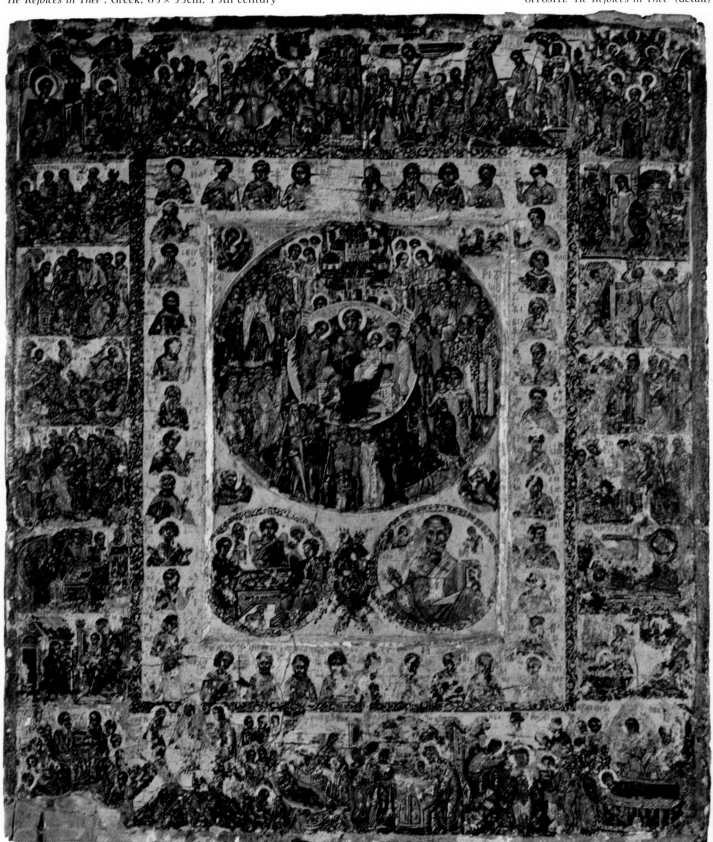

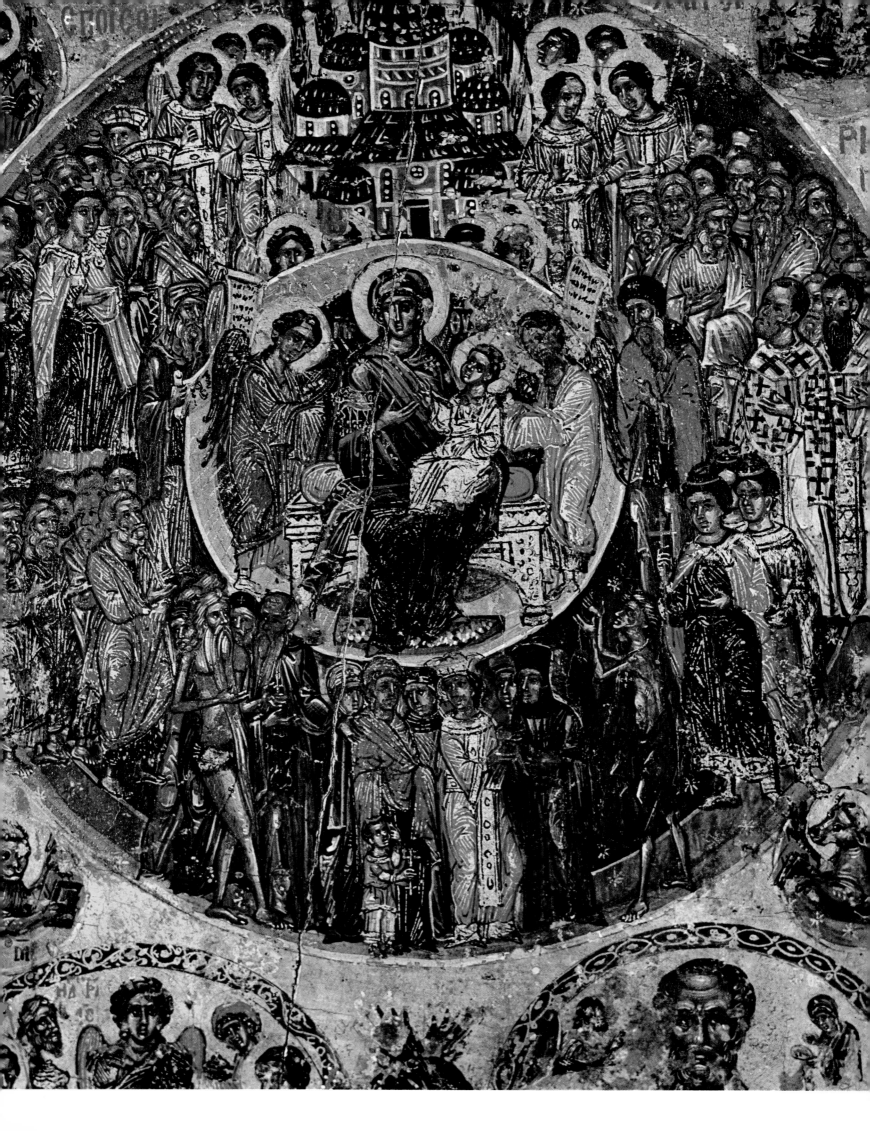

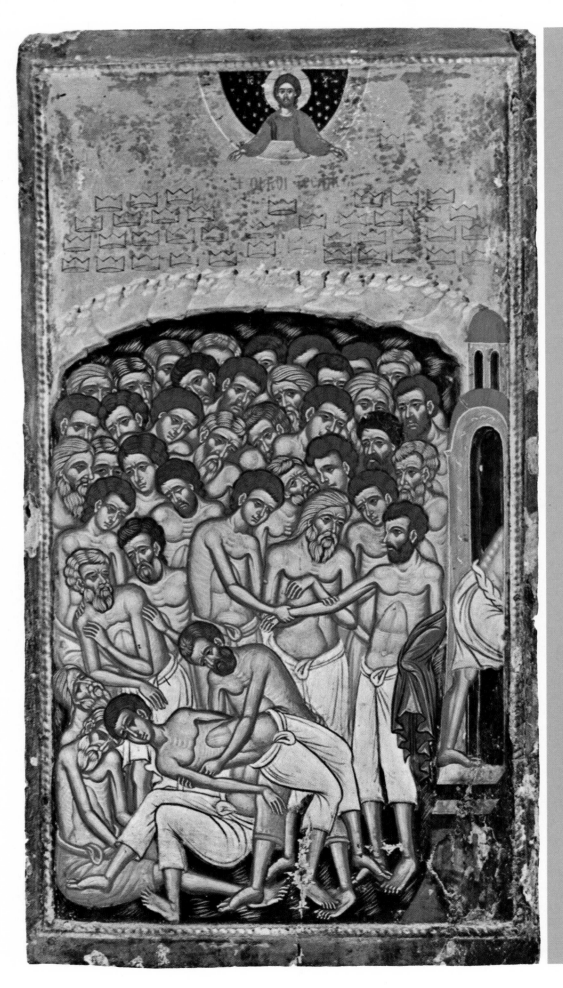

Forty Martyrs of Sebaste,
School of Central Greece,
112 × 60cm, 17th century

In 320, forty soldiers
under the Emperor
Licinius were martyred
for their faith. They were
compelled to stand all
night in an ice cold lake
near Sebaste, in Armenia,
before being executed. In
the painting, one soldier
has fainted. Another has
relinquished his faith, and
enters the warm bath
house. The overseer,
called St. Candidus by
Dionysius of Fourna,
takes off his himation, or
upper garment, and joins
the thirty-nine. Thirty-
nine martyr's crowns
descend; the fortieth,
destined for St. Candidus,
is removed a little above
right. Christ in heaven
blesses them. The earliest
picture of this scene is
found in an eighth-
century fresco in Santa
Maria Antiqua, in Rome.
The cycle in Ochrid,
Yugoslavia, has, in addi-
tion, the decapitation of
the survivors of the lake.
The Theodore psalter,
made in Constantinople in
1066, has an interesting
interpretation. The execu-
tioners, who throw stones,
are themselves injured,
and blood pours from
their heads. The dogmatic
significance of forty is
that the number had been
sanctified by Jesus's fast
of forty days in the desert.

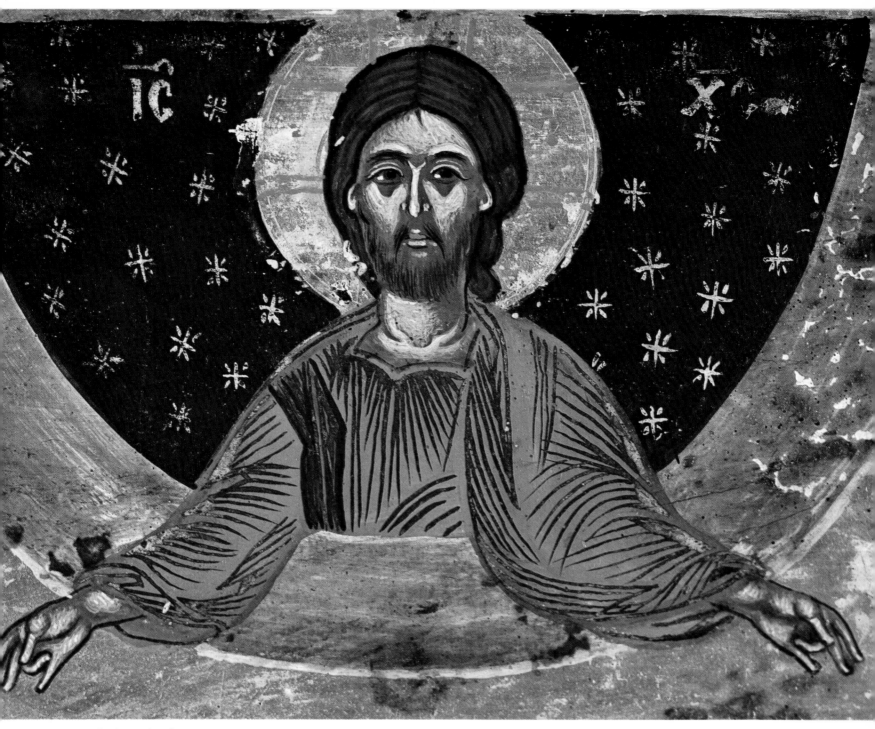

Forty Martyrs of Sebaste (detail)

Iconography and style

The specific content of an icon, which carries meaning, is known as iconography. Since each scene was divinely inspired, and its creator merely an intermediary, the iconography of the various scenes tended to remain the same over many centuries. This conservatism in content had a basis in teaching as well as in dogma. Pope Gregory I felt that imagery could be used to help the illiterate to understand the scriptures. He said, 'Painting is used in churches, that they who are ignorant of letters may at least read on the walls by seeing what they cannot read in books.' Of course the meaning of each item of the picture would have to be explained, but, once explained, it would act as a striking image, easily located with its own special position in the church, to aid the

memory. Pope Gregory wrote to the Bishop of Marseilles, who had destroyed icons, and said, 'In that you forbade them to be adored, we altogether praise you, but we blame you for having broken them . . . To adore a picture is one thing, but to learn, through the story of the picture, what is to be adored, is another.' For example, in the representation of the 'Forty Martyrs of Sebaste' one would commonly expect to see the forty martyrs, the apostate, and the warm bath house into which he retires, as well as the martyr fainting, and Christ, or the hand of Christ, blessing the martyrs from a mandorla or segment of heaven, with forty martyr's crowns descending. This is the case in *The Forty Martyrs of Sebaste*, which is a particularly full example of the iconography available, but it is possible to have the same scene with some details missing. For instance, in a miniature mosaic of the

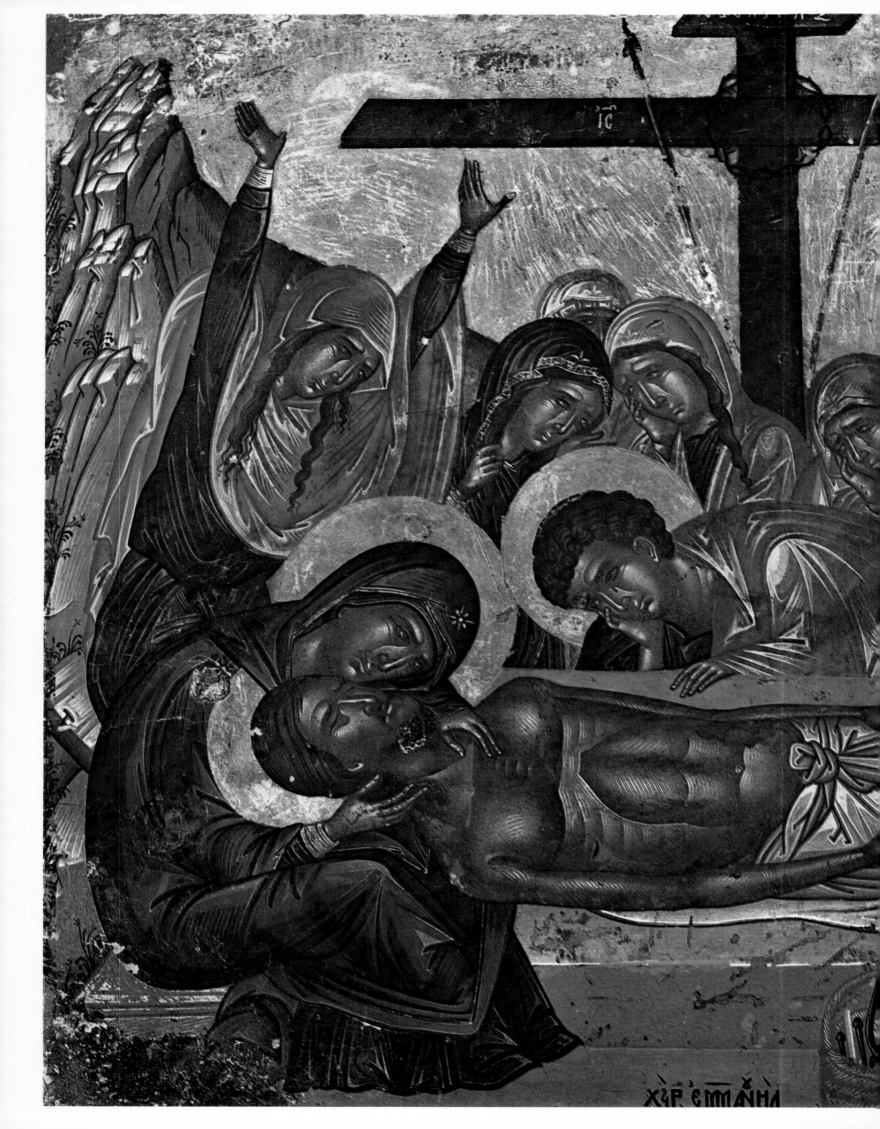

ΧΆΡ ΕΜΜΑΝΆΗΛ

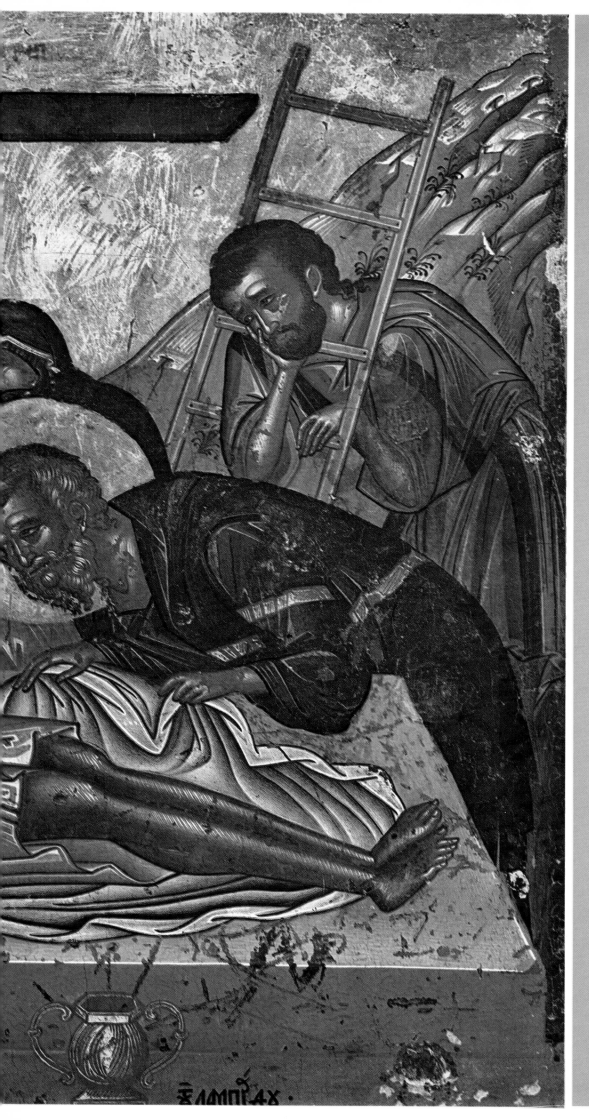

Lamentation, Emmanuel Lambardos,
41×52cm, 16th–17th century

The dead Christ lies on his back on the
anointing stone, with a winding sheet
unfolded upon it. The Virgin Mary cradles
his head in her arms, and touches his cheek
with hers. John, the young man with a
halo, looks sorrowfully on, crouching down.
Joseph, also with a halo, stands at the
foot of the stone, with the winding sheet.
Nicodemus leans on a ladder and looks at
Christ. Next to the Virgin, Mary Magdelene
throws her arms up high to either side,
weeping, while other women look on.
Behind them is the cross with the tablet,
and beneath Christ, the basket of Nico-
demus with the nails and pincers and
hammers, and near them another vessel,
like a small pitcher.

The lamenting of the dead Christ is not
mentioned in the Gospels; the scene has
been adapted from paintings of the Dormi-
tion of the Virgin Mary, where it was
included as part of the life of the Virgin.
The composition appears in its final form in
a Serbian fresco of c.1164, in the church at
Nerezi, in Yugoslavia. There, Joseph and
Nicodemus worship at the foot of the
stone, and John takes hold of Christ's
hand, and kisses it. The inclusion of John,
the best-loved disciple, is not based on any
text, and arose like the scene itself, out of a
desire to increase the emotional impact of
the Passion episodes.

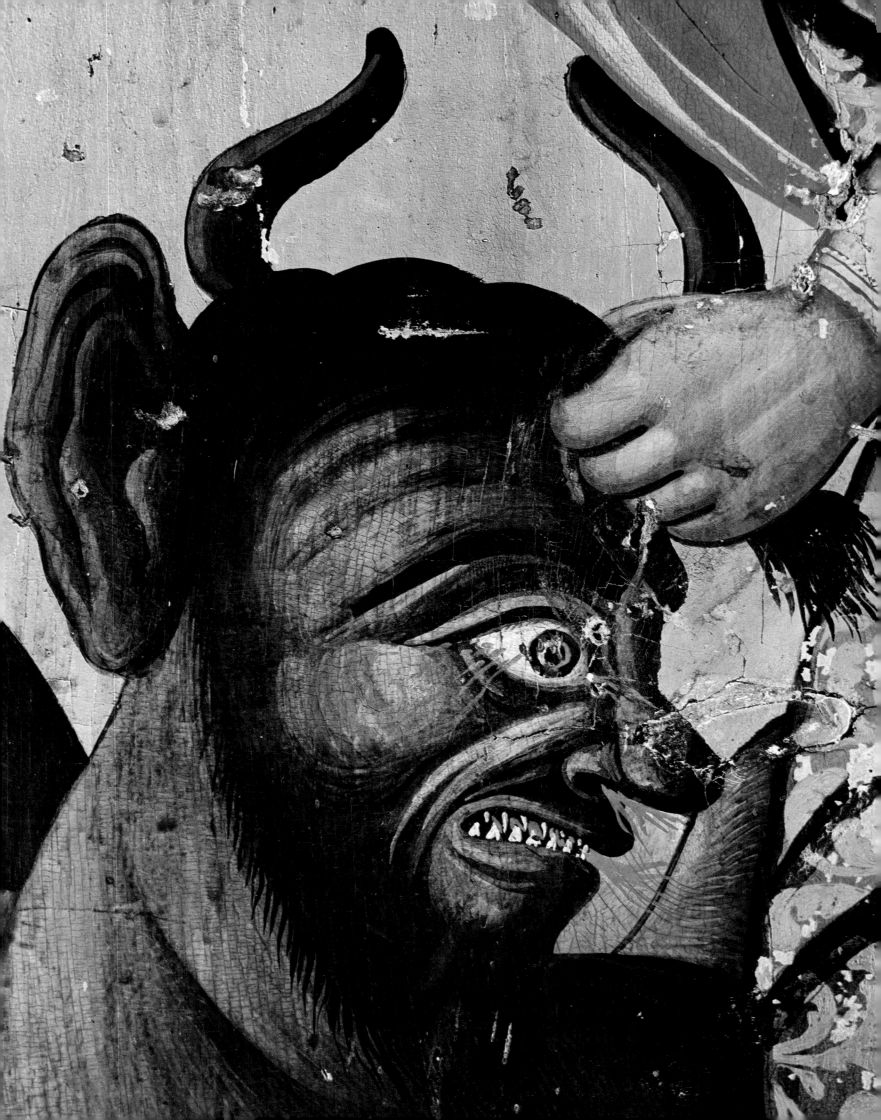

early fourteenth century, made in Constantinople, the bath house and the apostate do not appear, while in an ivory relief of the same period the artist has omitted the apostate and the descending crowns.

Sometimes a change in iconography can mean a change in dogma. In the Rabula Gospels of 586, the crucified Christ is shown in a long tunic (*colobium*) with his eyes open, to emphasize the divine nature of his being. This type existed until the early eighth century, as can be seen in the fresco of the Crucifixion in SS. Maria Antiqua, in Rome (705–8). However, in an eighth-century icon in the Monastery of St. Catherine on Mount Sinai, the figure of Christ, still dressed in

Confession (detail), unknown artist, early 19th century

a *colobium*, is shown with his eyes closed. This feature emphasizes the human suffering of Christ the man. A similar depiction exists in the Chludov psalter, which dates from the ninth century, and was thought to be the earliest picture of the dead Christ. We know now that the dogmatic insistence on Christ's human death upon the cross was not a post-iconoclastic invention, but was already current during the eighth century, within the period of iconoclasm. The next stage in the development of Christ on the cross was to replace the long tunic with a loincloth, to slightly overlap the legs, and finally to allow the body to slump upon the cross and to hang from the nails of the crosspiece and the foot-rest. The aim of the artist has been to heighten the emotional impact of the scene, and examples of these stages can be found in the miniature painting in the book of homilies of Gregory of Nazianzus (made between 880 and 886) and in

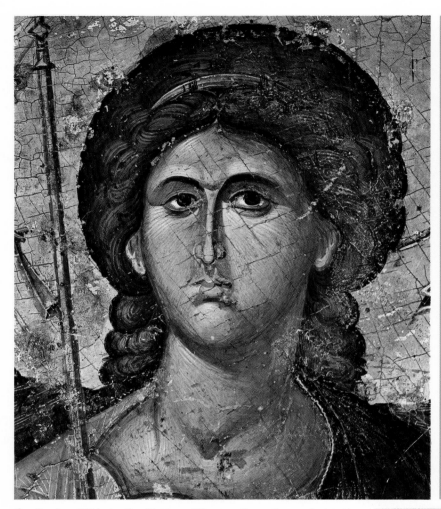

Archangel Michael, School of Constantinople, 110×80cm, and details, 14th century

The Archangel Michael is described as the Great Taxiarch, or captain of the hosts. In his right hand he holds the staff of a messenger, and in his left he carries a transparent orb, surmounted by a cross. The letters inside the globe make up the initials in Greek for 'Christ the Righteous Judge'. Michael is presented with a youthful, beardless face. The use of modelling in the face to enhance the illusion of depth is masterly in this painting, and does not conflict with the abstract streaks of light upon the forehead, the cheekbones, chin and neck. The play of light upon the garments is represented much more schematically, but with grace. Michael has a halo, and ribbons from his hair fly out on either side. The wings form the perfect setting for the noble head. This icon would most likely have been one of a series of icons of half-length figures that form part of a Deisis. In the Deisis, Christ is flanked by Mary and John the Baptist, with angels and saints on either side of them.

the Regina Bible in the Vatican Library, from the early tenth century. In this way, slight changes in iconography indicate certain new theological points of view.

The iconography of a particular scene tended to remain fairly static; the Gospels were not subject to change, and the scene was supposed to be read like a picture book. When we come across unfamiliar iconography, it is not always clear what the scene was intended to mean. One such example exists in the Church of St. Clement in Ochrid, southern Yugoslavia, which is filled with unusual scenes. One of the scenes is the bed of Solomon, which is surrounded by soldiers, and upon which rests an icon of the Mother of God with the Christ Child. It is difficult to determine the exact meaning of what is shown, in which an icon from Christian times is thrust into the presence, and upon the bed, of a great leader of the Old Testament.

If it was important for iconography to remain static, and if changes in iconography meant important changes in theological ideas, then there were similar constraints upon the style in which the icon was painted. No value was placed upon the individual expression of the personality of the icon painter; he was purely an intermediary, who must be passive, and submit to the divine inspiration that would constitute his artistry. And yet, by the same token, a particularly fine interpretation of the style of a given scene could be seen as an especially blessed creation.

It is popularly held that Byzantine art consists of rather stiff figures, who stare formidably from a golden background. While it is true that a great many such figures exist, this was

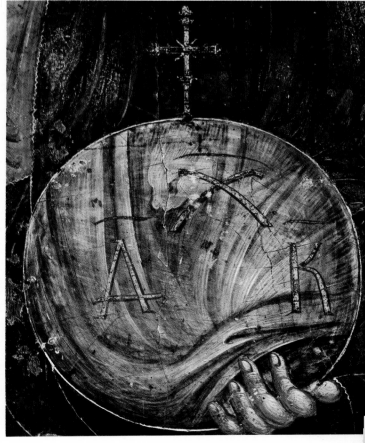

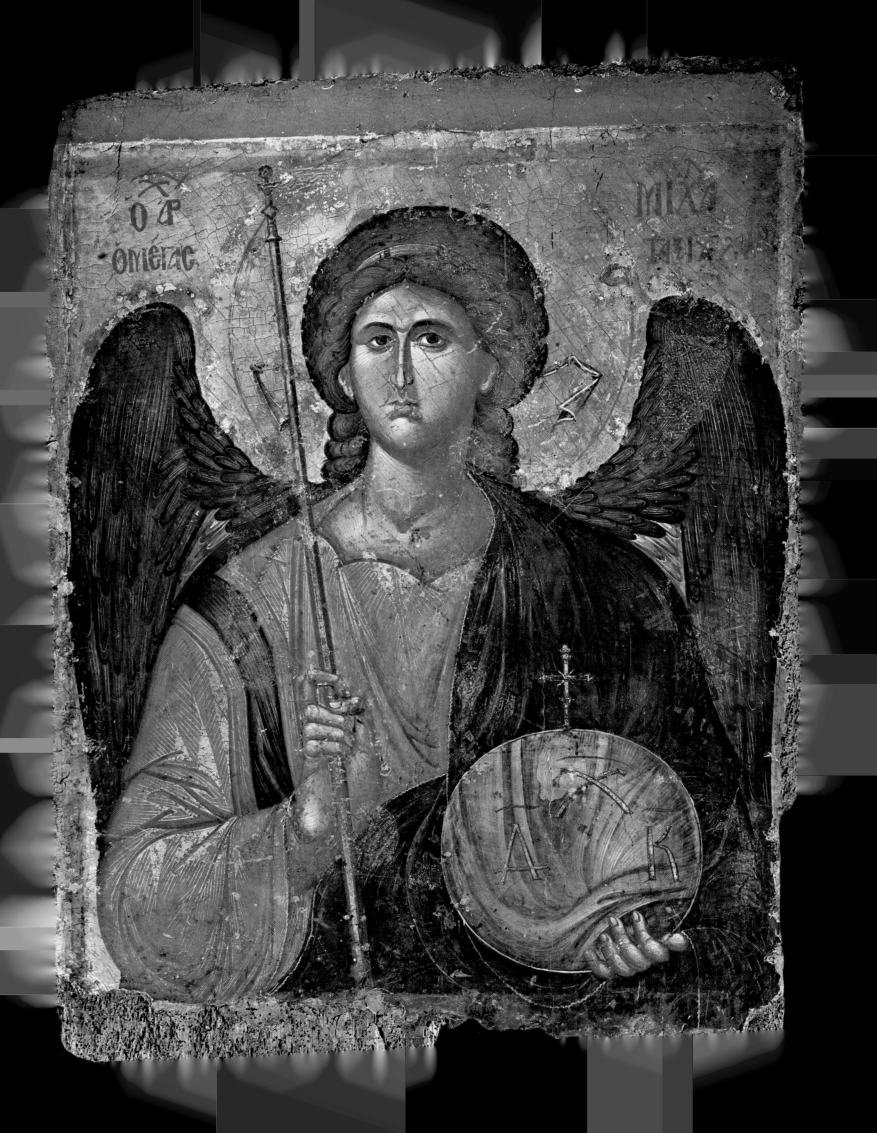

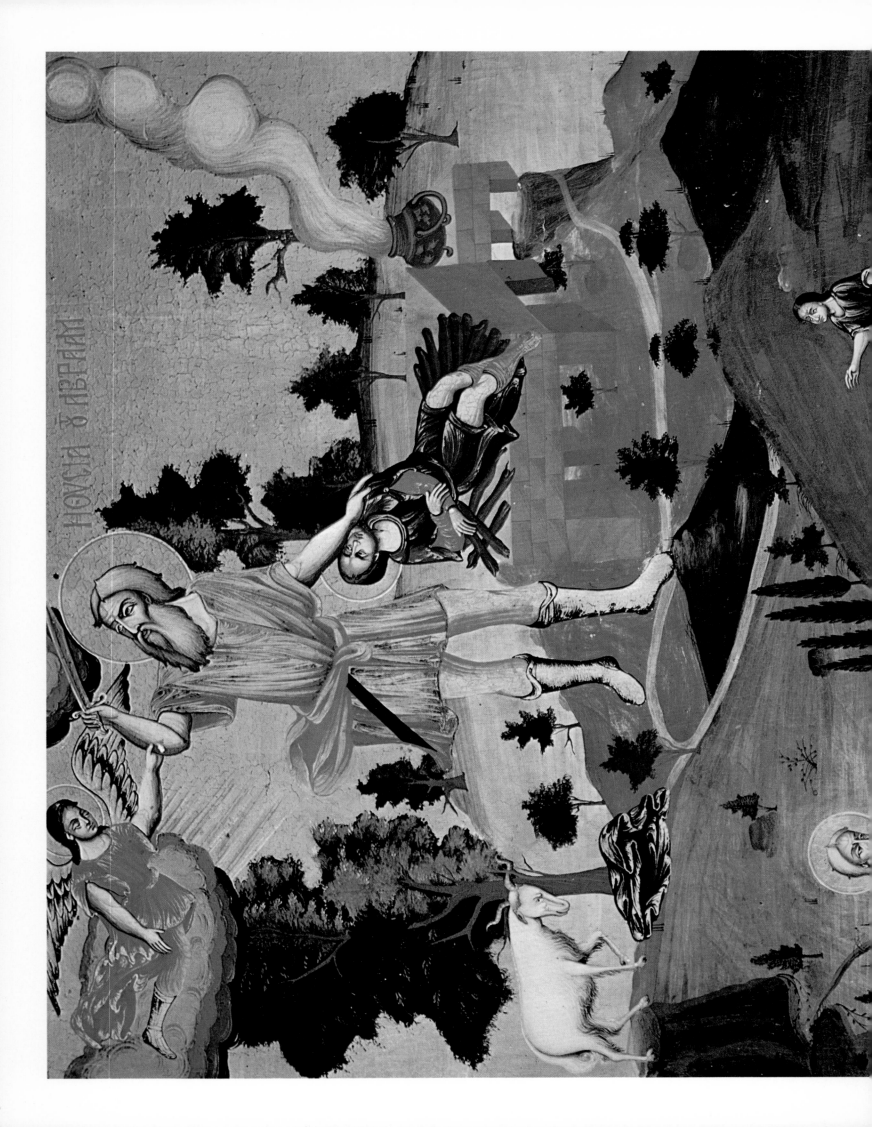

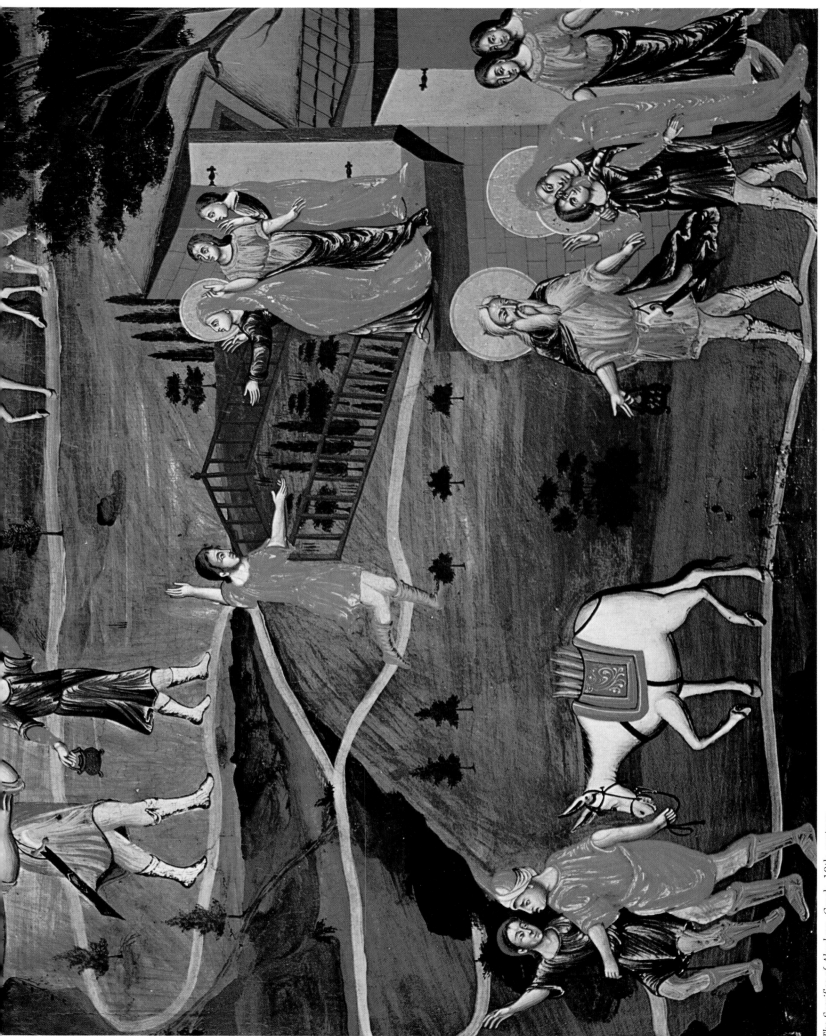

The Sacrifice of Abraham. Greek. 19th century

by no means the only style available to the Byzantines. Indeed, it is not surprising to find that stylistic changes occurred in a civilization that was over a thousand years old at its close. The frescoes in SS. Maria Antiqua in Rome date from different periods within the eighth century. One of the more recent layers contains the fully modelled face of a beautiful angel, which overlays a fresco containing a hieratic and stiffly posed figure. There is no simple line of stylistic development from Hellenic grace to Byzantine rigidity. Indeed, it is a characteristic of those icons dating from the end of the tenth century, when the number of icons painted increased, that the figures are more slender, and more elon-

Archangel, Ethiopian, 84 × 59cm, 19th century

St. Christopher with the Head of a Dog, from Asia Minor, 68×36cm, 1685

This icon is less unusual for its pictorial content than for the fact that it bears a date. The tradition of the dog-headed men (*cynocephali*), dates from very early times, and is common in Asia, Africa and Europe. The origins of the iconography are very obscure, and no less so is the reason why such an ancient tradition should have survived unchanged in Byzantine Christian times. Travellers told of creatures with animal form and human heads, or vice versa, that were supposed to have come from the region of the Nile or from Asia Minor, which seemed to be the edge of the world to Western men. Herodotus referred to strange creatures living in what was apparently a heavily wooded Libya, and wrote of a populace of strange beasts, asses with horns, men with dogs' heads, and men with no heads at all. Later stories that told of marvels of the east were transcribed and incorporated into other works, through the agency of the Byzantine scholar Photius from the ninth century onwards. In the Mercurius legend the cynocephali recall the ancient Egyptian cult of the jackal-headed Anubis. Two cynocephali devoured the grandfather of St. Mercurius, and were preparing to eat his father when an angel appeared and surrounded them with a ring of fire. They repented and became companions of the father, and later accompanied Mercurius into battle. St. Christopher is not the only saint to be thus represented. There is also St. Andrew of Cynocephali, in Kokar Kilise in Cappadocia, Turkey.

Virgin and Child. Florentine. 89 × 60cm. 13th century

gated than in some icons of earlier date. By the twelfth century two major styles were available to the painter: one, a rather elegant, though severe, manner, and the other favouring vivid and expressive modulation and colouring.

There is a famous icon in the Tretyakov Gallery in Moscow, entitled *Our Lady of Vladimir*, which was painted in Constantinople for the Grand Duke of Kiev, about 1130, and in 1153 was taken to Vladimir. It represents the development of a new type of icon, the Lady of Tenderness which is less formal and rigid than the earlier type and represents a new outlook. This iconographical change is shown in the style of the heads of Virgin and Child, who cease to be only symbolic of the Christian faith, and become the epitome of an intimate relationship. The ethereal qualities, on the other hand, of figures in such scenes as the crucifixion are produced by the elongation of figures, and are characteristic of work made in Constantinople after it was regained by the Greeks from Latin occupation in 1261.

Greek icon painters were sometimes forced to leave Constantinople, Thessalonika, or Asia Minor, and many of them probably settled for a time in Serbia and Macedonia, modern Bulgaria and Yugoslavia. The characteristic features of the

Defence of Novgorod against the Troops of Suzdal, School of Novgorod, 171 × 126cm, and detail, 15th century

The incident depicted here is a political feud between the cities of Novgorod and Suzdal, in which the victory of Novgorod in 1169 was attributed to a 'wonder working' icon. The story begins in the top right hand corner: the Bishop of Novgorod is going to the church of the Saviour outside the town, where the miraculous icon was held. He carries the icon over the Volkhov bridge, and the clergy follow. The people greet them and take the icon to the Kremlin. In the second register, envoys from each camp try to reach a settlement. Helmeted figures look on from windows in the walls. But the soldiers of Suzdal loose their arrows and graze the icon, which turns and sheds tears. In the bottom register, the soldiers of Novgorod repel the invaders, aided by four nimbed figures, and supported by heaven in the form of an angel. This icon was painted at a time when Novgorod was again under attack, this time from Moscow, and indeed the city was captured in 1471.

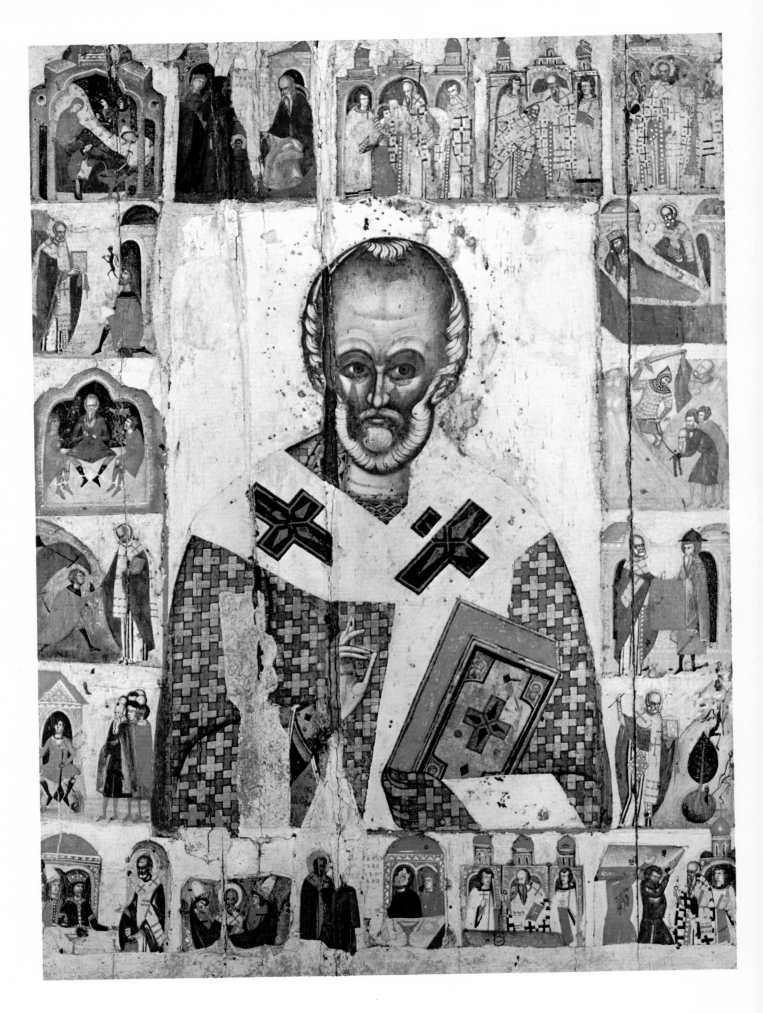

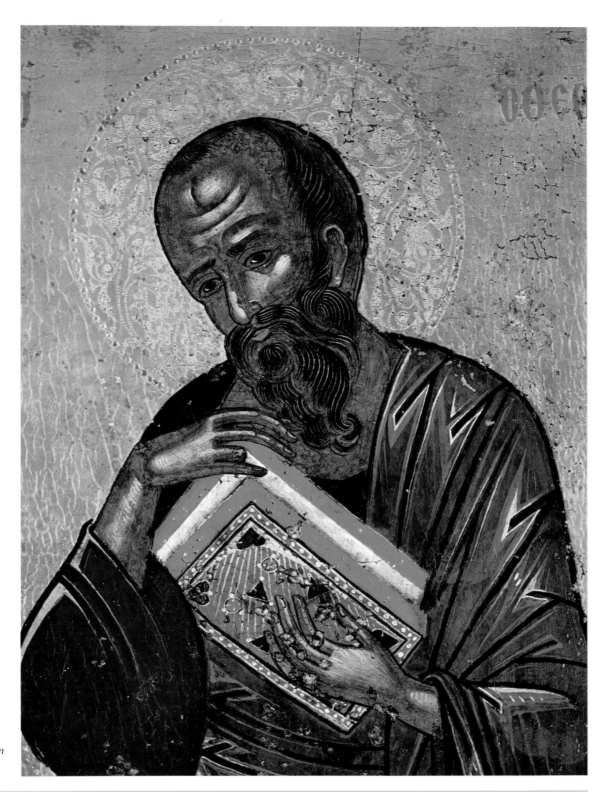

St. John the Theologian (detail), School of Crete, 16th century

Left *St. Nicholas and Scenes from his Life*, School of Moscow, 138 × 96cm, 14th–17th century

St. Nicholas, dressed as a bishop, holds a decorated book and blesses with his right hand. He is surrounded by eighteen scenes from his life. The story begins in the top left hand corner, where his mother has given birth and two women make ready the bath. He is supposed to have stood upright in this bath, and this was regarded as a manifestation of Divine Grace. In the next scene he is taken by his father to be taught his letters. Next we see him ordained deacon, priest and bishop. Below the scene of the birth, we see him driving the devil out of a possessed man. In the right hand margin he appears to the Emperor Constantine in a dream, and intercedes on behalf of some tribunes who were condemned to death when they returned to Constantinople, having been falsely accused of treason. In another incident, Nicholas halts the execution of three innocent citizens by grasping the sword. Further down this margin we see him driving demons out of a well by cutting down a tree that was dedicated to a pagan cult. In two other panels we see St. Nicholas saving the distressed mariners who prayed to him, and rescuing a drowning man. In the bottom left hand corner, we see him releasing a boy who had been captured by the Saracenes, while in the bottom right corner we see his death and the transportation of his body.

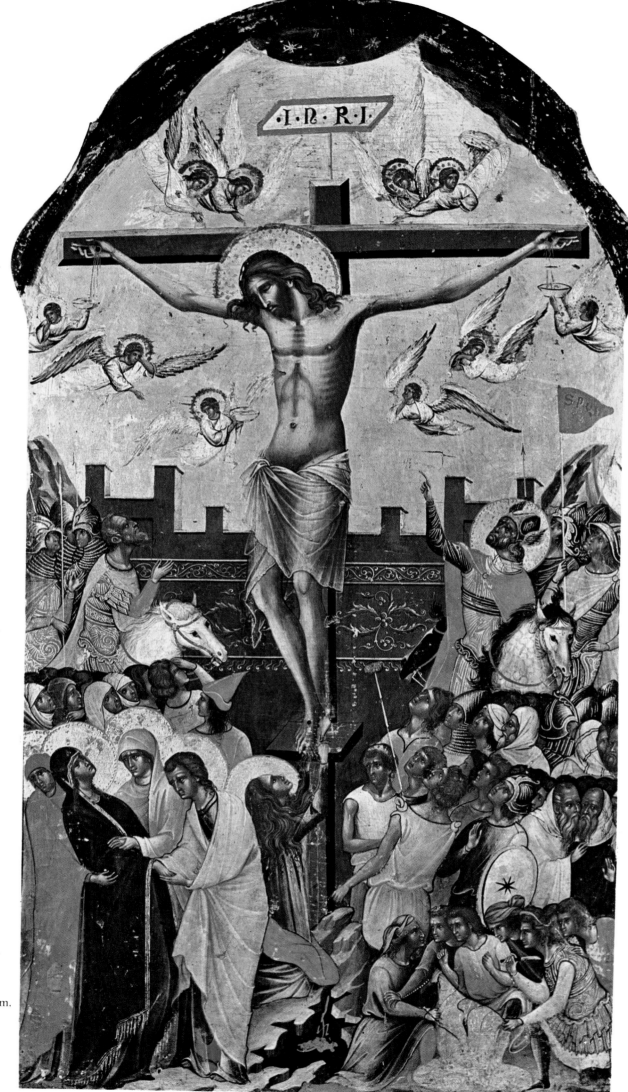

OPPOSITE *Crucifixion* (detail), Venetian

LEFT *Partition of Christ's Robe* (detail of *Crucifixion*)

BELOW LEFT AND RIGHT *Crucifixion* (details)

work of this area, made by the indigenous Slav population are not obvious. In comparison with work made in Constantinople in the thirteenth century, Serbian work is perhaps more sombre and painted with a broader brush, as well as being more agitated and angular than was the style in Constantinople.

It is equally difficult to isolate stylistic groups within the area of what is now modern Greece, with the exception of the islands. These are exceptional because the island painters used to sign their work. When Constantinople fell to the Turks in the mid-fifteenth century, Crete was already a colony of the Venetians, and remained so until the seventeenth century. Many Greek painters migrated to this haven, and it was as a result of contacts with the West that Cretan

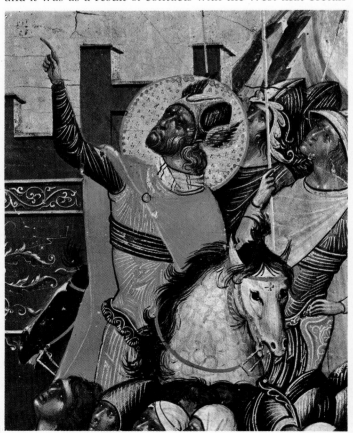

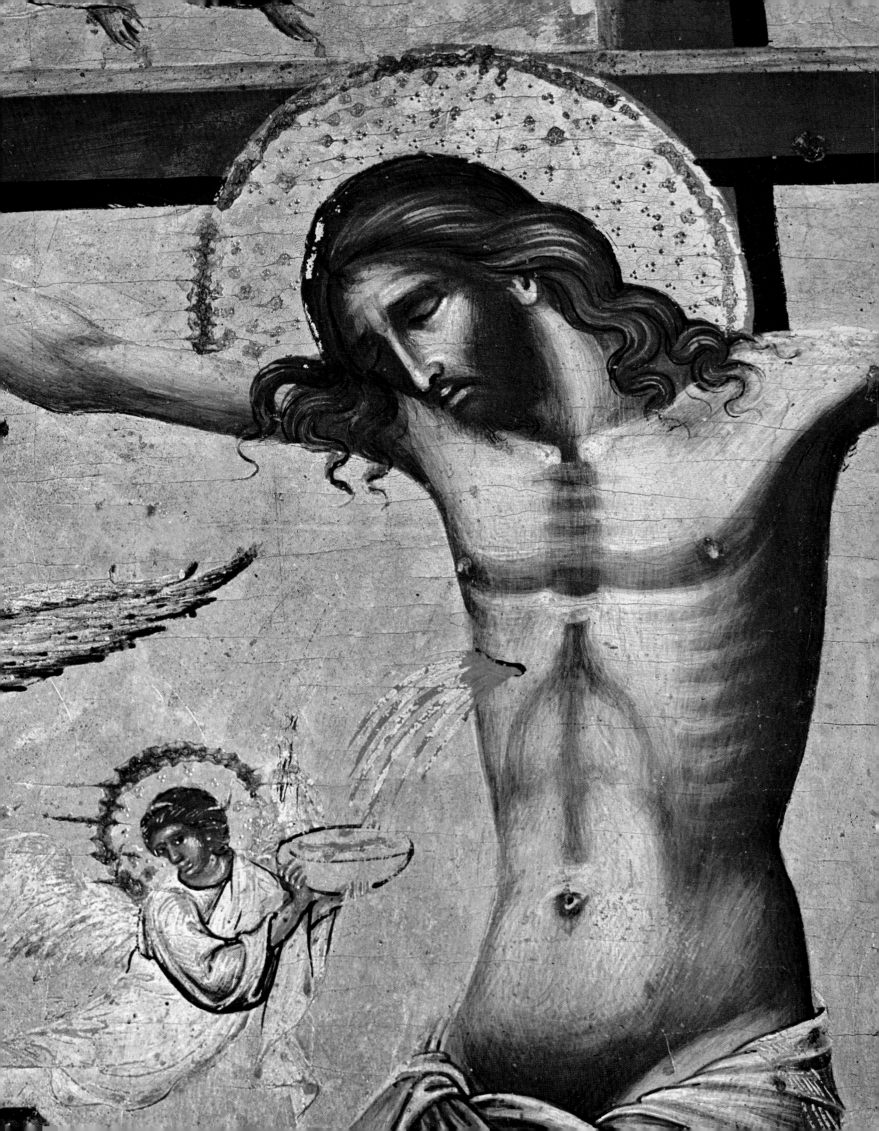

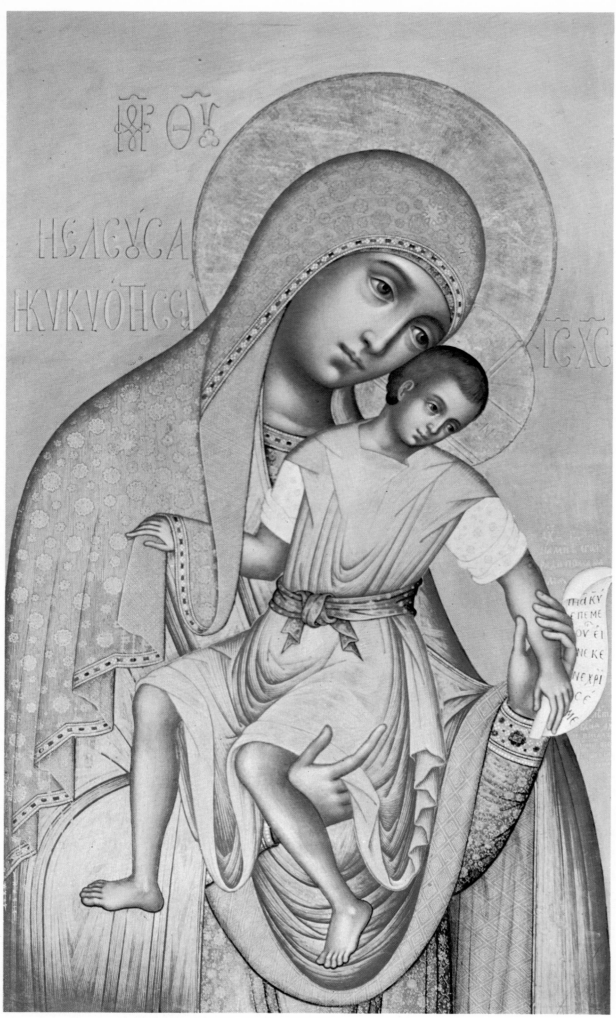

Our Lady of Kykkos, Simon Ushakov of Russia, 130·5 × 76cm, 1668

painters began to sign their work and claim for themselves recognition as individual artists, which had not been the practice among icon painters in the Byzantine period. The icon of St. Anthony was painted by the most important Cretan artist at the end of the sixteenth century, Michael Damaskinos. He went to work in Venice in 1574, when he was about twenty-four years old, and painted twenty-three of the icons in the church of San Giorgio dei Greci in Venice. He stayed in Venice for some years, so that later icons, added to the church in 1582, have some advanced Italianate elements; when, however, he later returned to Crete, his work again became more conservative and more satisfactory. The icon of St. Anthony is a particularly fine example; the scroll says, 'I saw the snares of the devil laid out upon the ground'.

Among the next generation of Cretan painters was Emmanuel Lambardos, who is represented here by *The Lamentation*. Although he, too, spent some time in Venice, his work retained the characteristic 'Byzantine' style of Crete, which was undoubtedly conservative in the early seventeenth century but which demonstrates the power of this style, ideologically and effectively, long after the Byzantine Empire had disappeared.

A third Cretan painter, called Emmanuel Tzanes (1610–90), is represented in this book by three icons, a Christ enthroned, a Christ Pantocrator, and a Virgin and Child. He was born in Crete, but lived most of his long life in Venice, where he served as a priest in the church of San Giorgio dei Greci. He tended to be conservative in his painting of single figures, and he had a love for ornate baroque detail.

Victor of Crete is represented here by the rich icon of St. Catherine. He always signed his work with his first name only, and his surname is not known. He lived in the islands of Greece, but visited Venice between 1674 and 1676. By the end of the century, the Venetians had lost control of Crete to the Turks, and the continuity of Cretan work influenced by Venetians, and the introduction to the West of a living Cretan tradition, came to an end.

The Grand Duke of Kievan Russia was converted to Christianity in 988, which coincided with the period in which figurative art was re-established in Byzantium. However, the demand at that time was for mosaics and frescoes rather than for icons, since the developed iconostasis did not then exist. The losses caused by the Mongol invasion of 1240 and by their occupation of many centuries were enormous. The earliest Kievan icon, *Our Lady of Vladimir*, of 1130, has been mentioned above as it was made in Constantinople. Indeed

Resurrection of Christ, Elias Moscos, 69 × 52cm, 1657

it was to Constantinople that Russia looked for its iconography, although stylistically the changes are marked. Most obviously, these changes are seen in the rounder heads and features of the Russian figures, compared with the pear-shaped faces and longer noses typical of the Greeks; this is clear in the icon *Our Lady of Kykkos*, of 1668. The icon, though late, demonstrates the general strength of Russian icons. The iconography is a variation upon a theme: usually in this type, the Virgin indicates Christ with her left hand, but here she tenderly holds his forearm. The high quality of modelling in the faces lends a degree of realism, which is countered only by the beatific expressions upon their faces. These qualities are blended with a considerable degree of abstraction in the balance of Christ upon the Virgin's right arm, as well as the strong patterning of their garments. This icon can speak for the best Russian characteristics: economy of detail and elegant solutions to complex pictorial problems. This icon retains the curious tension that must exist between reality and abstraction, and so remains traditional; but at the same time, it lacks drama, and suggests a heightened religious fervour, and greater serenity, than many Greek icons. The Russian icon may be seen as the perfect fruition of the Byzantine tradition.

Pages 78–9. *Dormition of the Virgin*, Russian, 67 × 49cm, 16th century

The Virgin Mary lies dead upon the bier, and Christ in a mandorla receives her soul. He is surrounded by a multitude of angels, and a seraphim with six wings. The angels have brought the twelve apostles miraculously from all parts of the world to the deathbed. At the foot of the bed is St. Paul, and at the head, St. Peter. The men in garments with large crosses are bishops, and they all have haloes. They are St. James, the first bishop of Jerusalem, and three disciples of the apostles, described by Dionysius of Fourna, as Timothy, Hierotheus, and Dionysius the Areopagite. Behind the bishops are a group of women who represent the faithful of Jerusalem. A candle appears in front of the bier; it relates to the Apocrypha of John of Salonica, which says that the Virgin lit a candle when an angel informed her that her death was imminent. In other representations of the scene the Jew, Jephanios, is shown having his hands severed for daring to touch the deathbed. Some early Church Fathers elaborate on this, and say that the hands were made whole again and the Jew converted to the Christian faith.

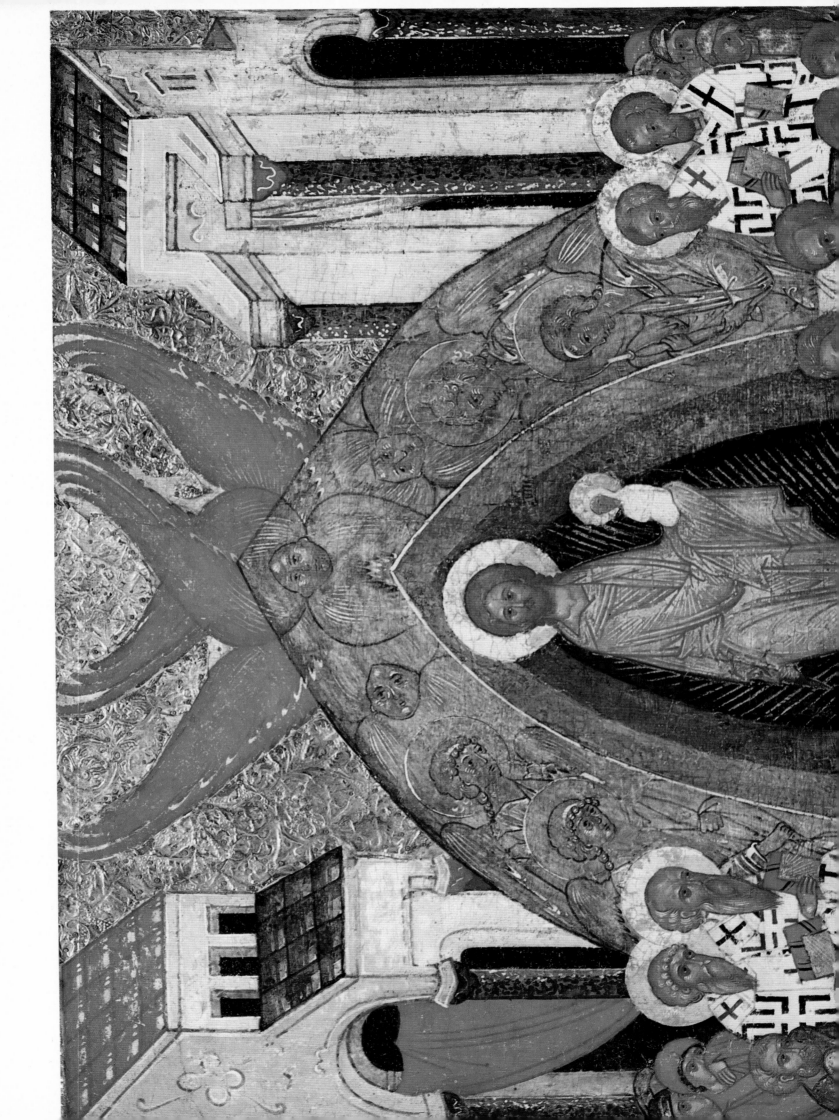

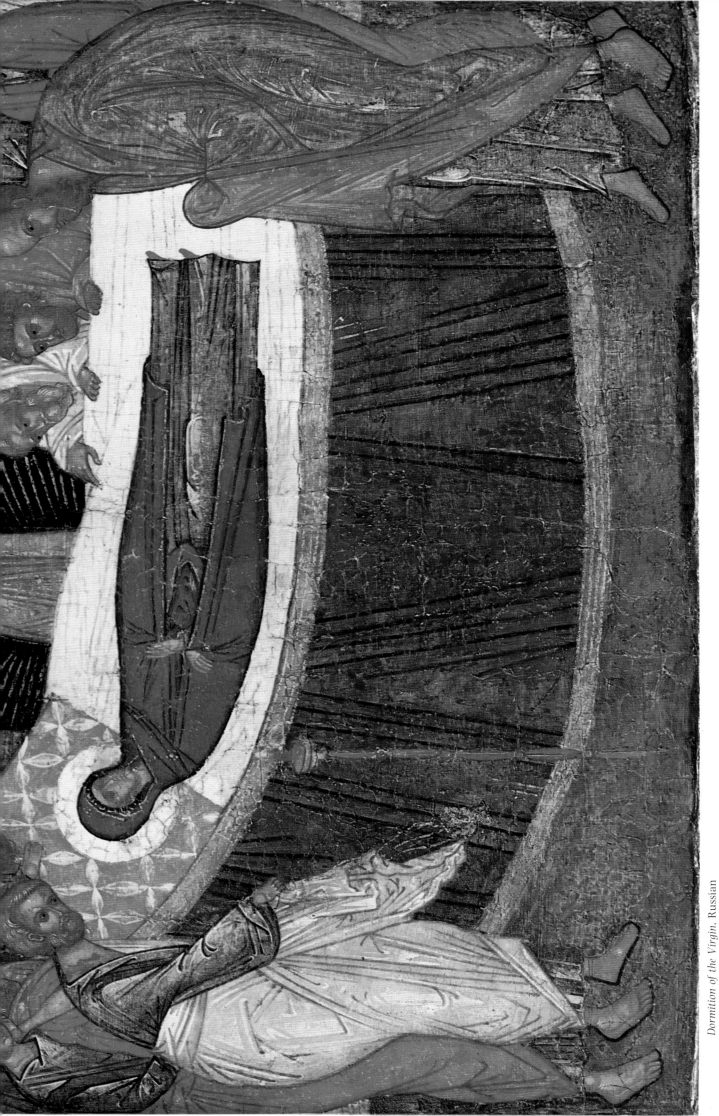

Dormition of the Virgin. Russian

List of Illustrations

Bibliography

ONASCH, K.: *Icons*, 1963
OUSPENDKY, L. AND L.: *Meaning of Icons*, 1968
PAPAGEORGIOU, A.: *Icons of Cyprus*, 1969
SKROBUCHA, H.: *Icons in Czechoslovakia*, 1971
TALBOT-RICE, DAVID AND TAMARA: *Icons and their Dating*, 1974
WEITZMANN, K.: *Icons from South Eastern Europe and Sinai*, 1968